TURNER: THE FOURTH DECADE

IAN WARRELL

Turner: The Fourth Decade

WATERCOLOURS 1820–1830

TATE GALLERY

cover
Dover *c*.1825
detail (cat.no.20)

ISBN 1 85437 057 X
Published by order of the Trustees 1991
for the exhibition of 29 January–12 May 1991
Copyright © 1991 The Tate Gallery All rights reserved
Designed and published by Tate Gallery Publications,
Millbank, London SW1P 4RG
Photography: Tate Gallery Photographic Department,
cat.no.1 photographed by John R. Freeman & Co.
Typeset in Monophoto Baskerville by
Keyspools Ltd, Warrington
Printed and bound in Great Britain by Balding + Mansell plc,
Wisbech, Cambs on 150gsm Parilux Cream

CONTENTS

FOREWORD

This exhibition continues our decade by decade exploration of Turner's watercolours and drawings. Although the beginning of the 1820s found Turner at the peak of his maturity, he continued to develop, and many of the works included in this display find him still experimenting with the application of his media. Turner's palette was liberated during these years – a transformation originating in his journey to Italy in 1819, and naturally Italian subject matter occurs in many of the watercolours. The scenery of England also stimulated several important groups of finished drawings during the decade, most notably the undertaking of the *Picturesque Views in England and Wales*. Unfortunately, since Turner sold all the watercolours from this series during his lifetime there are no *England and Wales* subjects in the Turner Bequest, although the Tate Gallery does own the watercolour of 'Aldborough'.

Other important omissions from the Bequest have been compensated for by the generous loan of works from private collections, the Birmingham City Museum and Art Gallery, the British Museum and the Herbert Art Gallery, Coventry. We are most grateful to all owners for these loans.

The exhibition has been selected and catalogued by Ian Warrell who is grateful for constructive advice and generous encouragement from Cecilia Powell and Peter Bower, the first two Volkswagen Turner Scholars. Later this year Cecilia Powell will be providing fresh insights into the watercolours Turner made recording his travels in the Ardennes, works which have been dated in the past to this decade. Special thanks are also due to others who have readily proffered their time and advice: Iain Bain, Sir Charles and Lady Dunphie, Jay Fisher and Kimberley Shanekch at the Baltimore Museum of Art, Ann Forsdyke, Anthony Griffiths, Hilary Williams and the staff of the British Museum Print Room, Rosalind Turner, Andrew Wyld, and Andrew Wilton.

Nicholas Serota *Director*

INTRODUCTION

After a hazardous journey across the Alps, Turner arrived back in London from his first visit to Italy in February 1820. He was forty-four years old and by then established among England's foremost artists. During the next ten years his work underwent a radical change, the roots of which lay in his experience of Italy. The spirit of Italy haunts much of his work in these years, both in the large oil paintings which he exhibited at the Royal Academy ('Rome from the Vatican. Raffaelle Accompanied by La Fornarina, Preparing his Pictures for the Decoration of the Loggia' (B & J 228); 'The Bay of Baiae, with Apollo, and the Sybil' (B & J 230); 'Forum Romanum, for Mr Soane's Museum' (B & J 233)) and in the luminous watercolour evocations created for Samuel Rogers, Walter Fawkes and Charles Heath (see cat.nos.1, 52–57 and 86). Inevitably Turner felt compelled to return to this fertile source of inspiration, but this was not to happen until 1828, by which time his art had already been dramatically altered through his new-found understanding of colour and his commitment to a number of major engraving projects.

Among the commitments which awaited his return from Italy in 1820 was the completion of illustrations for the *Provincial Antiquities of Scotland*, for which Turner worked in collaboration with Sir Walter Scott

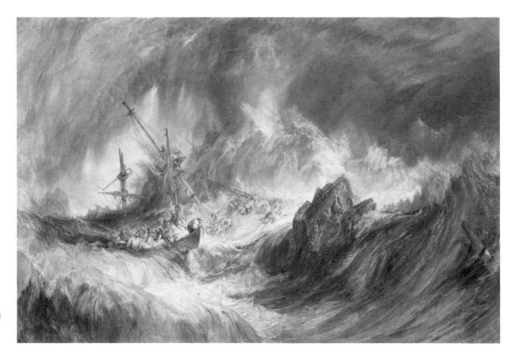

fig.1 'A Storm (Shipwreck)', Cooke's Gallery 1823, watercolour (on Whatman paper), 434 × 632 (17⅛ × 24⅞) (w 508). *Trustees of the British Museum* (1958–7–12–424)

[9]

(1771–1832). Secondly, there was what became the final stages of the *Picturesque Views on the Southern Coast of England*, published by William Cooke (1778–1855). Cooke was to prove a central figure in the projects with which Turner was involved during the early 1820s, commissioning and publishing the series of mezzotint views of the *Rivers of England* (cat.nos.10–15), as well as a number of large-scale watercolours for a projected group of *Marine Views* (fig.1 and cat.nos.7–9). In the finely crafted watercolours produced for the *Rivers of England* Turner painted what are some of his most beautifully atmospheric landscapes. However, this close working relationship led to a mounting degree of friction between artist and publisher: Turner grumbled about Cooke to the young Munro of Novar (one of his most important late patrons), complaining 'no holiday ever for me' (quoted in Shanes 1981, p. 11). But it was Turner's increasingly unrealistic contractual demands and the costs of the projected continuation of the *Coast* publication up the east coast of the country which precipitated a split between the two men at the end of 1826, at a time of a wider crisis in the engraving market.

The success of the *Rivers of England* encouraged Turner and one of its engravers, Thomas Lupton, to embark on a similar project – the *Ports of England* (cat.nos.17–21), which was not fated to achieve the degree of public support of the *Rivers*, and only six views were published. Other publications for which Turner planned watercolours, but which were only executed incompletely were a series of views of London (cat.no.30), his own *East Coast* (cat.no.59), and what promised to be a large-scale publication of views on both sides of the Channel (cat.no.60).

Central to Turner's artistic development in this decade is this involvement with the process of engraving. Having been immersed in this industry for well over twenty years he was thoroughly acquainted with the achievable effects of the black and white medium and the techniques that produced them. This assurance was, to some extent, challenged in 1820 with the introduction of harder and more durable steel plates, which were capable of far larger runs of an image without the plate needing readjustments by the engraver. From 1823 Turner's *Rivers of England* watercolours were being translated onto these new plates, and it was possibly this connection with his own work that stimulated the production of a group of mezzotints scraped and worked on copper and steel plates by Turner himself, generally known as the 'Little Liber'. The designs for these subjects were based on a number of loosely realised watercolours of sunrise, sunset, moon and cloud effects (cat.nos.22–25).

As a group, these are among the most important watercolours he produced during these years in terms of their wider effects on his art.

While the light of Italy had liberated Turner's palette, introducing a concern to approach a finer luminosity in watercolour and oil, these mezzotints gave him an insight into the capacity of darkness to project colour much more brightly. In watercolour this comprehension finds its outlet in the choice of coloured papers as supports and the use of brilliant bodycolour (or gouache). The oil painting 'Boccaccio Relating the Tale of the Birdcage' (B & J 244) demonstrates Turner's application of this kind of perception to his practice in oils; the castle is painted a bright white making it stand out from its surroundings. Similarly, the imaginative sunset of 'Ulysses Deriding Polyphemus' (B & J 330) owes its richness to the understanding gained through the kind of colour chiarascuro also found in the many studies of cloud effects made during this decade (cat.nos.27–29).

The increasing brightness of Turner's work was noticed and criticised by his contemporaries, particularly his dazzling use of yellow – something Turner joked about privately, claiming 'I must not say yellow, for I have taken it *all* to my keeping this year, so they say, and so I meant it should be' (Gage 1980, no.116). The reaction of critics to his 1825 picture of Dieppe (fig.2), serves as a characteristic example of much criticism of his

work during these years. His 'poetic colouring', as one of the reviewers termed it, challenged their expectations of what they considered appropriate to a northern coastal seaport. Henry Crabb Robinson wrote, 'No one could find fault with a Garden of Armida, or even of Eden, so painted. But we know Dieppe, in the north of France, and can't easily clothe it in such fairy hues' (see B & J 231).

This new luminosity was arrived at through a greater interchange between the techniques of oil and watercolour painting, encouraging an experimentation which saw Turner applying watercolour washes as a final film to several of his canvases. In train with this there was an increasing use in his private watercolour practice of loosely structured preparatory stages. Often these provide no more than the basic suggestion of a design, such as that of 'Stonehenge' (cat.no.37). But it is also possible with subjects such as 'Grenoble Bridge' (cat.nos.33 and 34) to watch the evolution of a design from little more than blocked-in colour masses to a highly finished picturesque view.

In 1822 Turner followed the recently crowned King George IV as he made a Royal Visit to Edinburgh. Turner had plans for a large-scale group of eighteen canvases on a par with the royal progresses of the great history painters, but only *modelli* survive for this project (see 'George IV at St Giles's, Edinburgh', B & J 247, 'George IV at the Provost's Banquet in the Parliament House, Edinburgh', B & J 248; Gallery 103). However, the King did commission Turner to paint a picture of 'The Battle of Trafalgar' to hang in St James's Palace. Although heroic in conception and composition, the details of the picture were criticised by the literal-minded marine experts of the court and it was eventually banished to Greenwich Hospital (B & J 252).

More successful commissions came from men such as John Broadhurst (views of 'Dieppe', B & J 231, and 'Cologne', B & J 232) and William Moffatt (two views of his house at Mortlake, B & J 235 and 239), as well as from the continuing patronage of Walter Fawkes. Until the death of Fawkes in 1825 Turner was a regular guest at the Fawkes' Yorkshire home, Farnley Hall, often spending Christmas with the family.

The middle years of the decade also saw the commencement of Turner's series of *Picturesque Views in England and Wales*, the largest project for engraving publication he had attempted since the conclusion of the *Liber Studiorum* in 1819. Issued by Charles Heath between 1826 and 1838, with a total of ninety-six published views, it constitutes Turner's most sustained analysis of the lives of his countrymen and their environment. The subject matter was all-embracing, from simple, atmospheric land-scape views to the bustle of a horse fair at Louth or the refined recreations

of the genteel classes at Richmond, and throughout it was peopled by professionals of all classes from shepherd to university don. Although Turner made use of notes from earlier sketching tours, his travels in England during this decade also contributed to this rich cross-section of the life of the nation (cat.nos.36–41).

In 1827 visits by Turner to the houses of two men were to result in commissions and provide artistic stimulus. The architect John Nash invited him to his home East Cowes Castle on the Isle of Wight so that the artist could record the castle in two views of the Cowes Regatta that summer. Turner was clearly excited by the experience and wrote to his father in London to send more canvas, on which he painted not only preparatory versions of the two finished views, but also evocative studies of the sky and the Regatta. This flurry of activity also resulted in scores of pencil sketches of the shipping around the mouth of the River Medina, as well as numerous pen and ink drawings on blue paper of the castle itself (see TB CCXXVII (a) and cat.nos.75–7).

Immediately before his stay with Nash, Turner had visited Petworth House in West Sussex, the home of George O'Brien Wyndham, third Earl of Egremont, who had been a patron between 1802 and 1814. Turner went back to the house after his stay at East Cowes and sometime during this year made a large group of coloured drawings on blue paper (cat.nos.61–74). Only a handful of Petworth subjects of this kind escaped from Turner's private collection. The whole series constitutes some of the most intimate and spontaneous of Turner's small-scale works. Lord Egremont owned an immense collection of old masters, but was also an important patron of contemporary artists. Subsequently Petworth replaced Farnley Hall as Turner's second home; he even established his studio in the Old Library at the house. The third Earl commissioned him at this time to paint four oblong landscapes to decorate one of the public rooms, providing the opportunity for Turner to deploy on a large scale the encircling panoramic effects he had already experimented with in watercolour (cat.nos.22 and 25).

Petworth in 1827 was also the scene for the conclusion of another venture, the series of watercolour vignette illustrations for Samuel Rogers's poem *Italy*, begun in 1826. These dazzling watercolours are immediately appealing, their bright colours still sparkling. In their engraved form they drew a wider audience than ever before for Turner's work: the combined sales of *Italy* and its companion volume of Rogers's *Poems* (1834) totalled 50,000 copies over seventeen years from the first appearance of *Italy* in 1830. Engravings of Turner's pictures were always the most accessible means for the public to see his work, but the designs of

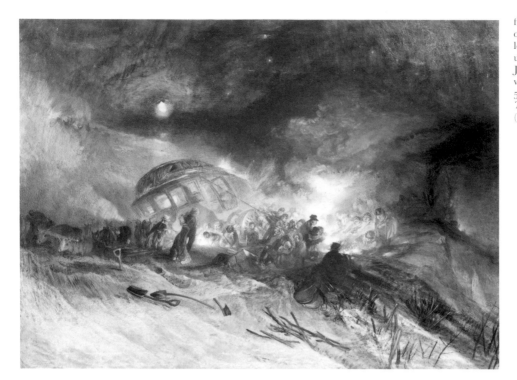

Italy were to become among the most influential. John Ruskin, who received a copy of the book for his thirteenth birthday in 1832, recalled them as 'the first means I had of looking carefully at Turner's work: and I might, not without some appearance of reason, attribute to this gift the entire direction of my life's energies.' (Ruskin *Works*, vol. XXXV, p. 29).

In 1828 Turner renewed his own acquaintance with Italy, travelling there via the River Rhône and the Piedmontese coast, an experience which in itself seems to have awakened a vibrant new use of colour. Very few of the sketches made in Rome on this trip demonstrate the meticulous recording of monuments and the atmospheric colour sketches so characteristic of his 1819 visit. Turner's preoccupation this time was the production of a companion picture for the Claude painting 'Jacob and Laban' owned by Lord Egremont, as well as a group of oil paintings which he executed and exhibited while in Rome. The display, in Turner's rooms near the Quattro Fontane, was attended by more than a thousand visitors, most of whom were puzzled by his art. One observer remarked, 'Turner's works here were like the doings of a poet who had taken to the brush' (quoted in Cecilia Powell 1987, p.142). He left Rome in January, travelling back across the perilously icy pass of Mount Tarare where he was caught in a snowdrift (fig.3).

Throughout the 1820s travel formed a regular part of Turner's life: he

made important trips to France in 1821, 1826, 1828 and 1829, and to the Low Countries and Germany in 1825 and, less definitely, in 1826. The extensive knowledge he acquired of the waterways of Europe led to the conception of a project to illustrate the *Great Rivers of Europe*, the first fruits of which were his views of the River Loire engraved in 1832, although an oil painting of this scenery appeared at the Royal Academy in 1829 (B & J 329).

Published projects such as this and *Italy* had attracted a huge audience for Turner's art – something he had consciously striven for when expanding his own gallery on Queen Anne Street in 1820. Between 1820 and 1830 his watercolours and paintings could also be seen beyond the confines of the Royal Academy at other London venues – Walter Fawkes's home in Grosvenor Place, Cooke's Gallery in Soho Square, and later the Egyptian Hall in Piccadilly; while outside London exhibitions in both Newcastle and Birmingham included examples of his watercolours.

Despite the widening forum for his work, Turner remained loyal to the Royal Academy, exhibiting a total of twenty oil paintings and two watercolours there in these ten years. He continued to give his series of lectures as Professor of Perspective, albeit somewhat erratically, until 1828, and he also took on new duties, becoming a Member of the Council, an Inspector of the Cast Collection and an Auditor of the Academy's accounts.

During this decade Turner suffered the deaths of important close friends; in particular of Walter Fawkes and, more significantly, of his father in 1829. His father had served him as companion, housekeeper, and studio assistant; one reason behind the sale of their house at Sandycombe Lodge, Twickenham in 1826 was the older Turner's increasing infirmity. A heightened awareness of the uncertainty of life caused by the loss of his father and his determination to be measured against the greatest of his artistic predecessors were the concerns upon which his first will was drafted in 1829. Despite later revisions, this was the first important step in the elaborate process by which the Turner Bequest came to the nation.

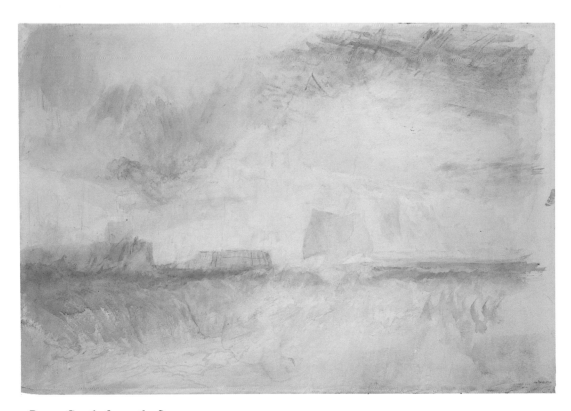

7 **Dover Castle from the Sea:**
 preparatory study 1822

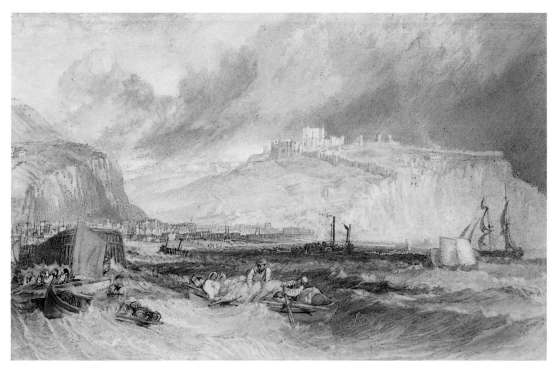

20 **Dover** *c.*1825

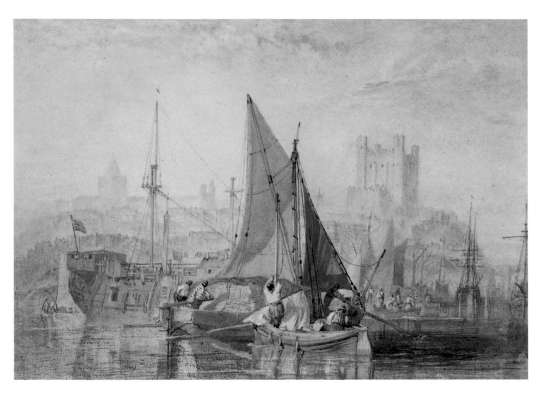

11 **Rochester, on the River Medway** 1822

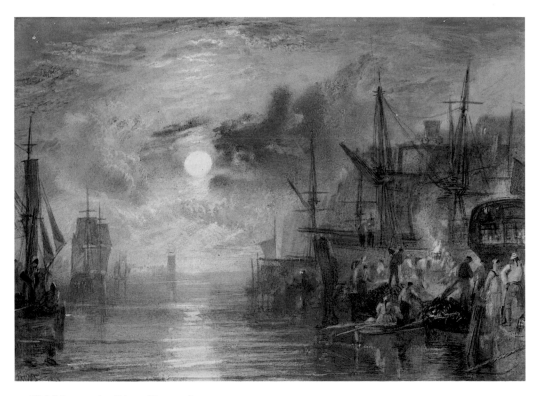

12 **Shields, on the River Tyne** 1823

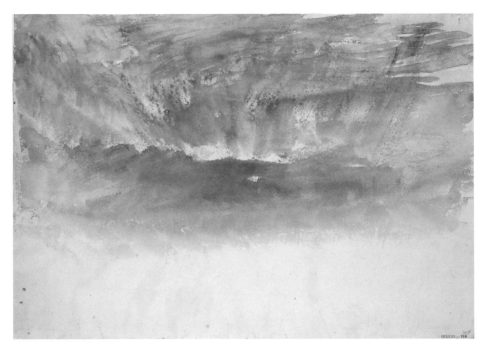

28 **Fiery Sunset** *c*.1825–7

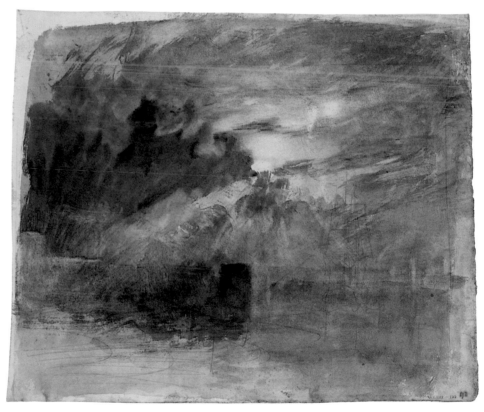

24 **The Moon behind Clouds: study for
'Shields Lighthouse'** *c*.1823–5

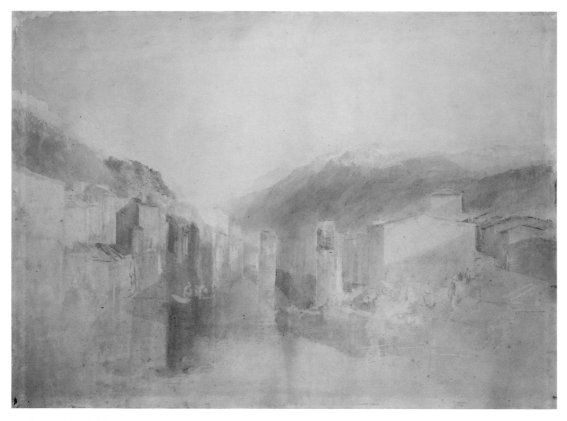

34 **Grenoble Bridge: preparatory study**
 *c.*1824

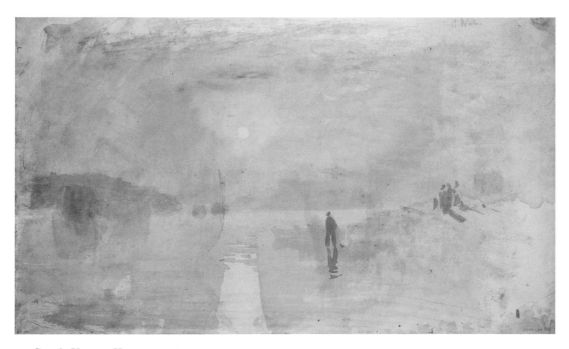

41 **Castle Upnor, Kent: preparatory
 study** *c.*1829–30

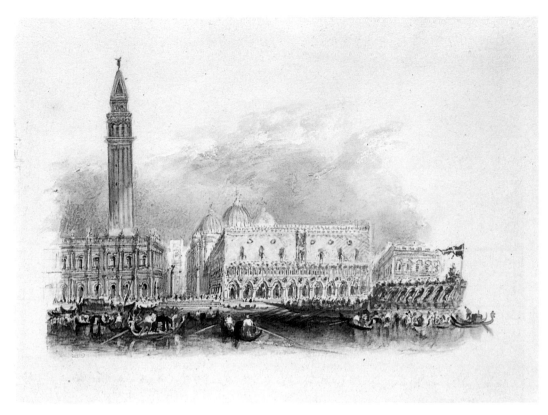

54　**Venice, The Ducal Palace**　1827

55　**The Ponte Vecchio, Florence**　*c.*1827

50 **St Florent** 1826–30

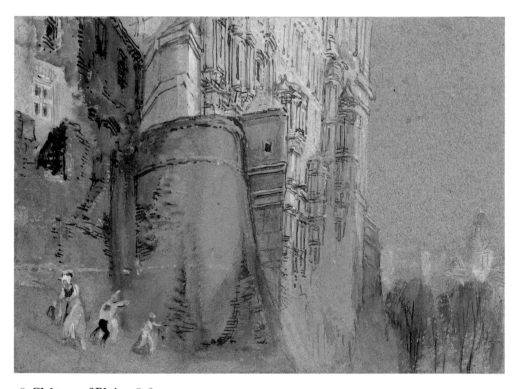

48 **Château of Blois** 1826–30

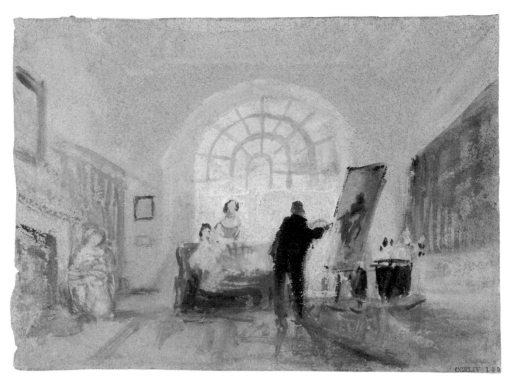

67 **The Artist and his Admirers** 1827

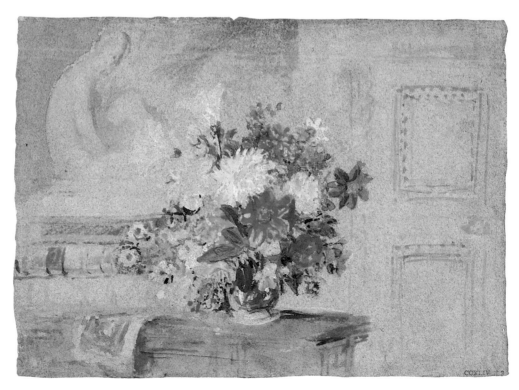

66 **The Old Library: A Vase of Lilies,**
 Dahlias and Other Flowers 1827

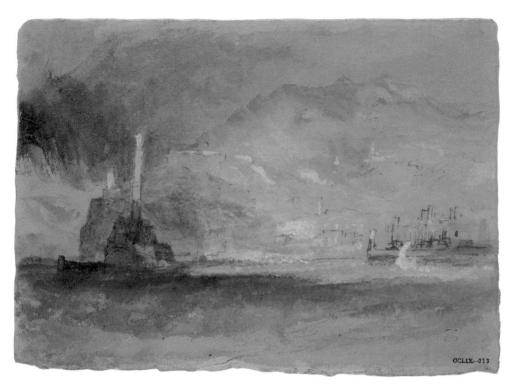

83 **Genoa from the Sea** *c.*1828

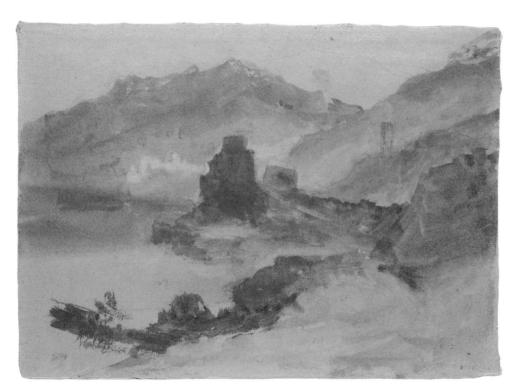

84 **Ruins and Cliffs on the
Mediterranean Coast** *c.*1828

CATALOGUE

Measurements are given in millimetres followed by inches in brackets; height before width. All items included in the catalogue are on white paper, unless otherwise specified. Any watermarks or inscriptions have been transcribed where legible.

Items illustrated in colour are marked*.

For other published material which is abbreviated in the text, see Bibliography.

Abbreviations

B & J Martin Butlin and Evelyn Joll, *The Paintings of J.M.W. Turner*, 2 vols., 1984 (revised edition)

R W.G. Rawlinson, *The Engraved Work of J.M.W. Turner, R.A.*, 2 vols., 1908–13

R L W.G. Rawlinson, *Turner's Liber Studiorum*, 1878 (1st edition)

T B A.J. Finberg, *A Complete Inventory of the Drawings of the Turner Bequest*, 2 vols., 1909

W Andrew Wilton, *The Life and Works of J.M.W. Turner*, 1979 (catalogue of watercolours)

1 **Snowstorm, Mont Cenis** 1820
Watercolour over pencil, with scratching-out
292 × 400 ($11\frac{1}{2}$ × $15\frac{3}{4}$)
Inscribed: 'PASSAGE/of Mt Cenis Jan 15 1820/ J M W Turner'
Birmingham City Museum and Art Gallery (409.53)
W 402

After several months in Rome in 1819, Turner travelled back across the Alps in January 1820. He recalled this crossing in a letter to the watercolour artist James Holworthy (1781-1841) in the equally cold winter of 1826: 'Mont Cenis has been closed up some time, tho the papers say some hot-headed Englishman did venture to cross a pied a month ago, and what they considered *there* next to madness to attempt, which honour was conferred once on me and my companion de voiture. We were capsized on the top. Very lucky it was so; and the carriage door so completely frozen that we were obliged to get out at the window – the guide and Cantonier began to fight, and the driver was by a

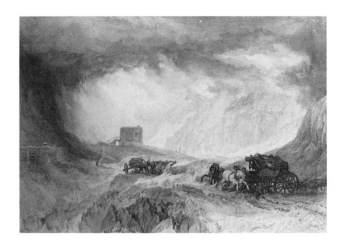

process verbal put into prison, so doing while we had to march or rather flounder up to our knees nothing less in snow all the way down to Lancesbyburgh [Lanslebourg] by the King of Roadmakers' Road, not the Colossus of Roads, Mr MacAdam, but Bonaparte, filled up by snow and only known by the precipitious zig-zag ...' (Gage 1980, no.112).

This watercolour recording the incident was made soon after his return to London, and is loosely based on pencil notes in the *Passage of the Mont Cenis* sketchbook (TB CXCII). Walter Fawkes bought the work for twenty-five guineas, as the artist recorded in a note in his *Paris, Seine and Dieppe* sketchbook in 1821 (TB CCXI f.10). Fawkes owned what was probably the largest private collection of Turner's watercolours, acquiring several views of Italy at the same time as this subject. It was during a visit to Fawkes's Yorkshire home of Farnley Hall that Turner had been inspired to paint the picture 'Snow Storm: Hannibal and his Army Crossing the Alps', exhibited in 1812 (B & J 126), which this work echoes in its vortex-like composition. While the rocks in the foreground recall in the sharpness of their delineation the sketches of 1802 made in the *St Gothard and Mont Blanc* sketchbook (TB LXXV), the brushwork and gradation of colour of the upper half of the picture is more expressive, anticipating the finished works of the next two decades.

The hazards of travel through the Alps formed the subject of another watercolour of this decade, again based on Turner's own experience, 'Messieurs Les Voyageurs on their Return from Italy (par la Diligence) in a Snowdrift upon Mount Tarrar – 22nd of January, 1829' (fig.3).

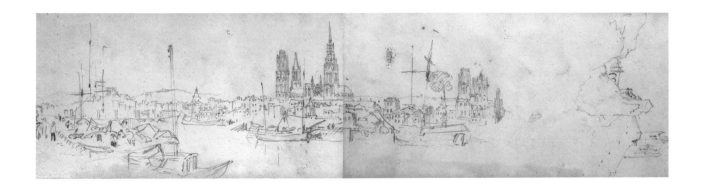

Dieppe, Rouen, and Paris sketchbook 1821

2 **Rouen from the South Bank of the River Seine**
Pencil
118 × 123 ($4\frac{9}{16}$ × $8\frac{1}{2}$)
Watermarked: J WHATMAN/TURKEY MILLS/1819
Turner Bequest; CCLVIII ff.6 verso, 7
D24511, D24512

In 1821 Turner revisited Paris, travelling down the River Seine and stopping at Rouen where he made pencil sketches that were eventually to serve over a decade later as the basis for the bodycolour designs engraved in his *Annual Tour – the Seine* (1834, W951–70; 1835, W971–90). The architecture of the cathedral seen in this view helps date the sketch to the period prior to 15 September 1822, when the spire was destroyed by fire. While in Paris Turner used this sketchbook on a visit to the Louvre where he recorded his impressions of paintings by Claude Lorrain, an artist he had been unable to study in his 1802 *Studies in the Louvre* sketchbook (TB LXXII).

3 **Study of Fish: Two Tench, a Trout and a Perch** *c*.1822–4
Pencil, watercolour and some bodycolour
275 × 470 ($10\frac{13}{16}$ × $18\frac{1}{2}$)
Watermarked: J W[HATMAN]/TUR[KEY MILL]
Turner Bequest; CCLXIII 339
D25462

3A **Tail and Head of a Fish; Colour Trials** [not exhibited] *c*.1822–4
Pencil, watercolour and some bodycolour
267 × 222 ($10\frac{1}{2}$ × $8\frac{3}{4}$)
Watermarked: [J W]HATMAN/[TUR]KEY MILL/1821
Inscribed in pencil by John Ruskin: 'Tail and head of Fish, cut off/to get centre in/to sliding frames. J.R. 1862.'
Turner Bequest; CCLXIII(a) 5
D25520

Fishing was something of an obsession for Turner (his rod is on display in Gallery 103) and earlier in his career Sir John Leicester of Tabley Hall had (with perhaps some justification) complained that Turner spent more time fishing than painting. He is also known to have caught fish near his Thames-side home at Twickenham, at Farnley Hall, and in the lake at Petworth (see cat.no.72).

An acquaintance with whom he discussed his passion

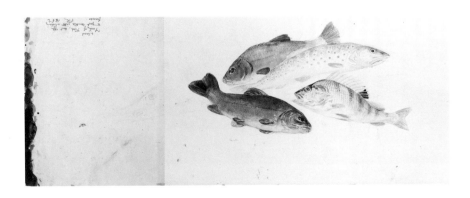

was his friend James Holworthy. Many of the letters between the two men in the early 1820s allude to the sport and it is possible that this sheet resulted from a visit to Holworthy's home at Hathersage, near Sheffield in Derbyshire (see Gage 1980, nos. 112, 116, and 119). It was perhaps a visit to Hathersage that also provided the occasion for the now untraced view of Derbyshire which appeared at the Royal Academy in 1827 (B & J 240).

In this watercolour he has captured the delicate colouring of the wet scales, what Ruskin termed the 'subdued iridescences' (Ruskin, *Works*, vol. XIII, p.370). Despite the exquisite finish Turner has brought to the various details, such as the golden underbelly of the trout, the work is incomplete and it is unlikely that it was intended either for sale or engraving (see Gage 1987, p.163). This assumption is reinforced by the fact that the sheet of paper on which it was painted was originally one-third larger; after Turner's death Ruskin, in selecting works to be displayed at the National Gallery, decided to doctor the sheet to provide a more exhibitable image. If the now detached fragment is brought alongside, a fifth fish head (possibly that of a pike) is joined to the faint pencil lines which disappear at the left-hand side of the main sheet. The smaller sheet also carries a group of palette studies in which Turner has tested his loaded brush to try the effect of the colours he intends to use, many of which can be found unaltered in the actual image.

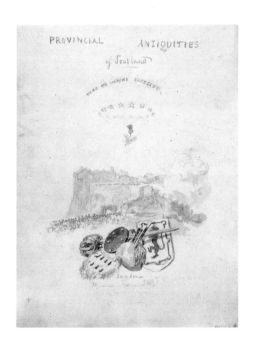

4 Frontispiece for Volume One of *The Provincial Antiquities of Scotland*: **Edinburgh Castle** 1822–5
Grey wash with some pencil
198 × 130 ($7\frac{13}{16} × 5\frac{1}{8}$), vignette; 241 × 178 ($9\frac{1}{2} × 7$), sheet size
Watermarked: [J WH]ATMAN/[18]15
Turner Bequest; CLXVIII A
D13748
W 1058

Walter Scott had originally commissioned Turner and several other artists to work on the *Provincial Antiquities of Scotland* in 1818. Turner visited Scotland that autumn and several watercolours resulted from the tour. Although the project was foundering a little by 1822, Turner made another visit that year, possibly influenced by the decision of George IV to go to Edinburgh, the first Hanoverian monarch to go north of the border. Turner was in Edinburgh from early in August and recorded the King's visit extensively in two sketchbooks (TB CC and CCI) with the intention of making a series of paintings of the Royal Progress (*modelli* for several of these can be found elsewhere in the gallery, B & J 247, 248, 248a, 248b). The King's visit, which lasted from 14 to 29 August, also stimulated Scott who suggested that Turner should include the events in two designs to serve as frontispieces for the final bound form of the *Provincial Antiquities*.

This vignette commemorates the return of the Regalia to Edinburgh Castle on 24 August; the foreground contains symbolic attributes of Scotland's past. The historic Regalia had only been rediscovered in 1818 through Scott's perseverance in searching Edinburgh Castle. The other frontispiece (TB CLXVIII B; W 1063) shows the King's boat anchored in Leith Harbour awaiting Scott's arrival – the meeting of England and Scotland is symbolised in a pair of hands shaking below that design.

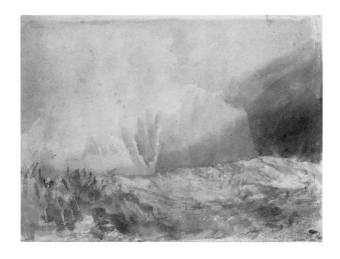

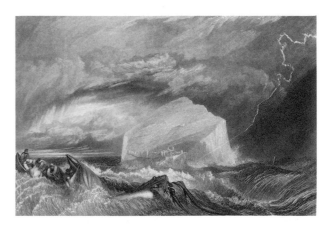

5 **Bass Rock: preparatory study** *c.*1822–3
Watercolour
200 × 264 (8 × 10⅜)
Turner Bequest; CCLXIII 205
D25327

This watercolour is a preparatory study for the finished view of Bass Rock (now in the Lady Lever Art Gallery, Liverpool, W 1069). Colour structures such as this were not a new feature of Turner's procedure, but from the early 1820s they become an increasingly significant part of the way he worked towards his finished designs, and were sometimes produced in batches marking a series of varying preparatory stages.

On his 1818 tour Turner had made pencil sketches of the spectacularly sited rock from the shore near Tantallon Castle (TB CLXV and CLXVII), but the composition of this view is closer to a drawing in the 1822 sketchbook (TB CC f.79) in which the rock is seen from this angle. The paint on this sheet has been applied with fluency, almost as an echo of the violent storm it depicts engulfing the rock. However, Turner has been careful to anticipate the general colour structure of the final picture, and the rock stands out from the darkness of the surrounding elements.

WILLIAM MILLER (1796–1882) after
J.M.W. TURNER

6 **Bass Rock** 1826
for *The Provincial Antiquities of Scotland*
Engraving, false proof R 200: image size 171 × 254
(6¾ × 10); laid on wove paper 343 × 508
(13½ × 20); plate mark 246 × 310 (9¹¹⁄₁₆ × 12¼)
T04501

This subject was published as Turner's final contribution to Scott's *Provincial Antiquities of Scotland*. The design here has been engraved on a copper plate with the print reproducing the finished watercolour's fine gamut of tones between light and dark in the more limited range of black and white. Miller has managed to convey the drama of Turner's original watercolour; the flash of lightning, in particular, contains a vivid note of heightened realism. Turner often used lightning in his work, notably in a view of 'Stonehenge' (cat.no.37) and a mezzotint in the 'Little Liber' series known as 'Catania' (W 774, R 805).

7 **Dover Castle from the Sea: preparatory study*** 1822
Watercolour over traces of pencil, with some bodycolour
475 × 682 (18¾ × 26¹³⁄₁₆)
Watermarked: J WHATMAN/TURKEY MILLS/ 1822
Turner Bequest; CCLXIII 378
D22502

From about 1817 William Cooke, the engraver and publisher, had owned a large watercolour by Turner of the Eddystone Lighthouse (W 506). He clearly en-

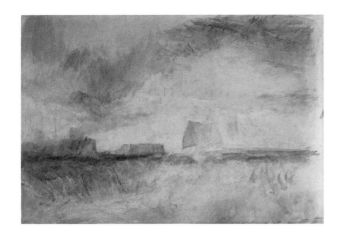

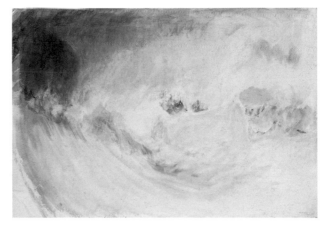

couraged Turner to make other large-scale water-colours of coastal scenery to be grouped together as a series of *Marine Views*, although eventually only two were engraved (R 772 and R 773), together with a wrapper decorated with a vignette of Neptune's trident (TB CLXVIII C). (The ownership of this vignette was a source of later friction between Turner and Cooke and precipitated the break between them early in 1827.) On 31 December 1822 Cooke held a private view of watercolours and recent engravings at his gallery at 9 Soho Square. The exhibition included Turner's large view of Dover Castle from the sea (w 505), for which the artist received 60 guineas. According to the catalogue, the picture was 'drawn in December 1822' (quoted in Shanes 1981, p.10). That Turner had anticipated painting a number of watercolours on this scale in 1822 can be ascertained from the fact that nearly all the preparatory studies in the Turner Bequest associated with *Marine Views* subjects are on paper manufactured by the Whatman paper mills in this year (see cat.nos.8 and 9).

This study is similar in composition to a watercolour view made in a sketchbook (TB CCII f.14), which more probably relates to the finished view executed for the *Ports of England* project (cat.no.20); the watercolour displayed here presents a closer view of the harbour. Both finished views show the paddle steamer service which by 1821 provided a regular crossing to Calais. The most distinctive part of this design is the outline of the castle which looms ethereally above the town.

8 **A Storm (Shipwreck): preparatory
study** 1822–3
Watercolour
388 × 484 ($5\frac{1}{4}$ × $18\frac{1}{16}$)
Watermarked: J WHATMAN/TURKEY MILLS/1822
Inscribed on lower edge, '[?] Wash als th lay in'
Turner Bequest; CCLXIII 379
D25503

Another of the *Marine Views*, displayed at Cooke's Gallery in 1823, was the watercolour referred to as either 'A Storm' or 'Shipwreck', which was put on display on 19 May (see fig.1). Often in Turner's work what appears to be a spontaneous and consummate statement was only arrived at through a series of trial stages. For the exhibited view of the storm he made at least three large studies, including this sheet, charting the colours and the basic composition structure (TB CCLXIII 371, 377). However, the finished picture reverses the composition of these studies, so that the trough of the wave rises from the centre to the right, not to the left as in this image. Consistent in all these studies is the choice of the dark orange for the protruding rock upon which the wave crashes. On this sheet the angle of the ship's deck and its mast are seen at a stage before that perilous dipping reached in the exhibition watercolour. There is, however, no indication of the figures which contribute to the presentation of sublime terror in the final work.

Turner had made drawings of the rugged coastline of Scotland in 1818 in his *Scotch Antiquities* sketchbook (TB CLXVII f.18 verso to f.23), and it may be that his recent visit to Edinburgh by boat in the early autumn of 1822 provided the stimulus for this scene, which does not seem to be based on any recorded shipwreck. Ruskin, in a slightly inaccurate generalisation, observed in the 1856 publication of the *Harbours of England* that Turner was unable to draw the coasts of Britain without suggesting disaster of this kind.

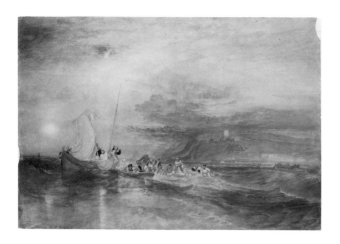

layers of watercolours are applied. This can be seen in the foreground where the technique is used to suggest the foamy edge of the waves. Not content with encompassing the opposing lights of both moon and dawn over sea and sky, Turner has included another source of light in the burning fire at the foot of the cliff upon which the church stands. This effect is reminiscent of the varied light sources deployed in one of his earliest oil paintings, 'Fishermen at Sea' (B & J 1; Gallery 107).

9 **Folkestone from the Sea** 1823–4
Watercolour with stopping-out and bodycolour
488×684 ($19\frac{1}{4} \times 26\frac{13}{16}$)
Watermarked: J WHATMAN/TURKEY MILLS/1822
Turner Bequest; CCVIII Y
D18158
W512

This watercolour, similar in finish to those made for the *Southern Coast of England* and the *Rivers of England* series, is most probably another of the *Marine Views* (see cat.no.7). One of two views of smugglers off Folkestone, the scene here is set in the early hours of the morning. A French boat is passing its barrels of illegal gin to a group of English smugglers. Alerted to the approach of a blockade boat on the right they quickly try to 'sink' their haul at a marked point intending to return later and retrieve their catch. This subsequent action is indeed the subject of the second watercolour (W 509), a sunset view, which is set further along the coast towards Dover, although St Mary's church at Folkestone is still visible on its headland.

A colour study related to this composition (TB CCLXIII 357) shows only the central boat with a figure on the lookout, and is perhaps an intermediate stage between the two smuggling subjects. Turner made specific pencil drawings of the cliffs around Folkestone in a notebook of around 1821–2 (TB CXCVIII), and there are colour studies in the *Ports of England* sketchbook (cat.no.17) which seem to show the outline of the church.

In this view he has used a variety of media and techniques, with touches of bodycolour over the watercolour to convey the reflected light on the sea. There is also evidence that he has used the technique known as 'stopping-out', whereby selected areas are treated with wax, gum or a similar 'stopping-out' agent, which prevents the treated area being covered as subsequent

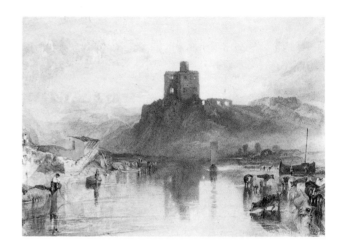

10 **Norham Castle, on the River Tweed** 1822–3
Watercolour, with some bodycolour
156×216 ($6\frac{1}{8} \times 8\frac{1}{2}$)
Turner Bequest; CCVIII O
D18148
W736

This watercolour was one of sixteen made for the *Rivers of England*, a publication intended by William Bernard Cooke to serve as a companion to the *Picturesque Views on the Southern Coast*. According to Cooke's account books, Turner was paid eight guineas for the loan of this drawing in 1823, which suggests that the artist had completed it either that year or in 1822. He had first visited and sketched Norham, in the border country of the North-East, on his 1797 tour and it was to be a recurring subject in his art, inspiring several watercolours and the famous oil painting (B & J 512, Gallery 101). One of the finished watercolours Turner had exhibited at the Royal Academy in 1798 was a view of Norham (W 226) accompanied by lines of poetry from Thomson's *Seasons*, which could also serve to illustrate this work:

But yonder comes the powerful King of Day,
Rejoicing in the East: the lessening cloud,
The kindling azure, and the mountain's brow
Illumin'd – his near approach betoken glad

However, in 1822 when Turner was making this watercolour his thoughts were with another poet – Sir Walter Scott, for whom he was designing illustrations for the *Provincial Antiquities* (cat.nos.4–6). Scott's work stimulated a watercolour of Norham made for Walter Fawkes at exactly this date (w 1052) in which lines from Scott's poem *Marmion* are illustrated:

Day sat on Norham's castled steep . . .

The composition in the watercolour exhibited is similar to that made in the *North of England* sketchbook (TB XXXIV f.57), although in comparison with the *Liber Studiorum* plate of the same subject (TB CXVIII D; RL 57), Turner has contracted the width of the design and heightened both the stump of the tower and the cliff on which it sits.

It has been suggested that this watercolour is among the first works in which the artist applies colours prismatically, following a system in which the primary colours, red, blue and yellow are juxtaposed. Turner is thought to have learned of this kind of colour theory through Sir David Brewster on his 1818 journey to Scotland. Another watercolour of the subject (TB CCLXIII 22) anticipates the prismatic effect achieved here.

Norham was among the earliest subjects executed for the *Rivers of England,* and was issued on 1 January 1824 as a mezzotint by Charles Turner, who had also engraved the view of Norham in the *Liber Studiorum.* The watercolour was later engraved again by Percy Heath in 1827 (R 317, unpublished), possibly as an illustration for the pocket annual, the *Literary Souvenir.*

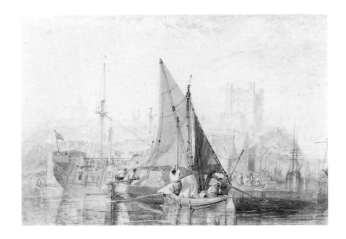

11 **Rochester, on the River Medway*** 1822
Watercolour
152×219 ($6 \times 8\frac{3}{5}$)
Watermarked: J WH[ATMAN]/TURKE[Y MILL]
Turner Bequest; CCVIII W
D18156
W 735

Another subject executed early in the *Rivers of England* project, this watercolour is based on a group of pencil sketches Turner made in a sketchbook used on the River Medway (TB CXCIX ff.10, 18, 18 verso, 19). Whereas most of the pencil drawings are spread over two pages – an opening measuring some 380 mm wide – he has managed here to contract the significant points of the view onto this sheet measuring only a little over 200 mm.

Turner had first painted Rochester in one of his earliest oil paintings, a work now untraced, showing fishing boats below the castle keep (B & J 21). In this watercolour the castle dominates what little of the town can be seen through the misty morning light, the tower of the cathedral almost evaporating into the luminous haze. In its published form the subject was accompanied by a description in guidebook terms by Mrs Barbara Hofland who discusses the history of the town and its monuments. In contrast, Turner focuses on the life of the river. The Thames barge at the centre is laden with hay, while its sails partly obscure what appears to be a prison hulk. As in the *Picturesque Views in England and Wales* watercolour of 'Aldborough' (cat.no.36), the chief delight of this watercolour is the rendering of minutely observed reflections in the slow surface of the river.

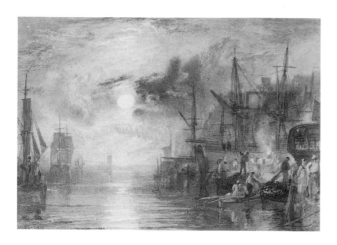

12 **Shields, on the River Tyne*** 1823
Watercolour
154×216 ($6\frac{1}{8} \times 8\frac{1}{2}$)
Watermarked: [WHA]TMAN/[TURKEY]
MILLS/[182]2
Inscribed, lower left 'JMWT 1823'
Turner Bequest; CCVIII V
D18155
W 732

Dated 1823 in the lower left-hand corner, this was one of two watercolours engraved in the first part of Cooke's *Rivers of England* and published on 2 June the same year. Both subjects were set on the River Tyne, the other being a view of Newcastle (TB CCVIII K; W 733). The Newcastle view harks back to a sketch in the 1801 *Helmsley* sketchbook (TB LIII ff.94 verso, 95), but both watercolours probably have their specific origins in Turner's 1818 journey through the region on his way to Scotland. The bold use of colour, contrasting the cool blue of the moonlight over the water with the man-made furnace-glow on the right, is Claudean in conception and balance. A.J. Finberg wrote that Turner made little or no concession to the engravers of this series in the colouring of his designs, a claim borne out by an overall similarity of tone in the final mezzotints regardless of the wide colour range of the originals. Indeed, the colours we now see may be duller than they were in Turner's day, for Rawlinson noted in 1913 that 'many have become seriously faded from continuous exposure' (Rawlinson 1913, vol.II, pp.364–5). Mrs Hofland, in her note on this scene, remarks on the extent of shipping at Shields 'engaged principally in the coal-trade, and loading in its port 400 vessels annually', as well as noting the town's other forms of growing industrialisation. The combination of moonlight and Shields lighthouse, seen in the distance here, served as the stimulus for several watercolours associated with the 'Little Liber' project in the years after this watercolour

(see cat.nos.22–25), as well as an oil painting closely related to the composition of this view which Turner exhibited at the Royal Academy in 1835 ('Keelmen Heaving in Coals by Night', B & J 360).

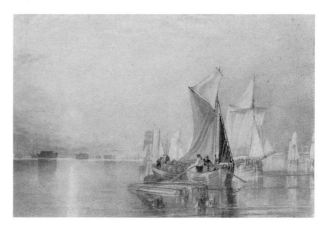

13 **Stangate Creek, on the River Medway**
*c.*1823–4
Watercolour
162×240 ($6\frac{1}{3} \times 9\frac{2}{5}$)
Watermarked: [WHA]TMAN/[TURKE]Y
MILLS/[18]22
Turner Bequest; CCVIII A
D18134
W 746

This is the second Medway subject included in the *Rivers of England* (see also cat.no.11). A third view exists, but has been associated in its mezzotint form with the 'Little Liber' series rather than the *Rivers* (TB CCVIII P; R 769 and 809a). Turner's published views for the project embrace twelve of England's rivers in sixteen views, the River Dart in Devon dominating his contribution to the publication with a total of three subjects.

Like the view of 'Rochester', this watercolour is lit by diffused dawn sunlight, and despite the details of quarantine hulks, sloops and river barges, the character of the light becomes the prevailing subject matter of the picture. The advertisements for the publication boasted that the 'style in which the plates are engraved is peculiarly adapted to the powerful effects of light and shade, in the varieties of Twilight, – Sun-rise, – Mid-day, – and Sunset'. For the published plate, Turner seems to have directed Thomas Lupton, who engraved it, to introduce a buoy to replace the floating logs to the left of the barge in order to provide a more strongly focused foreground (see cat.no.16).

14 **Arundel Castle, on the River Arun** *c.*1824
Watercolour
159 × 228 ($6\frac{1}{4}$ × 9)
Turner Bequest; CCVIII G
D18140
W744

During Turner's lifetime the River Arun was connected by means of a series of canals with the Thames providing a shorter alternative route to London from the South Coast. Although Turner concentrated on the river and barge traffic that made this journey in another, unpublished, Arundel view of this date (TB CCVIII F; W748), the river here is only glimpsed as a contributory detail as it flows beneath the walls of the castle, past the town's windmill, and on to the sea at Littlehampton. Turner visited Arundel sometime in either 1823 or 1824 making notes which relate to this scene in one of his smallest sketchbooks (*Brighton and Arundel*, TB CCX ff.69 verso, 70). As in other water-colours made for the *Rivers of England*, it is the weather conditions that dominate the design. They provide the dramatic veracity of a moment captured, with the feathery lines of fine rain clouds seen moving along the coast, throwing parts of the landscape into shadow amid the returning sunshine. The same type of cloud is also evident in an *England and Wales* watercolour (W854), while the unengraved view of the town ment-ioned above includes a rainbow, possibly suggesting that Turner witnessed a summer shower while on his visit to Arundel.

15 **Kirkstall Abbey, on the River Aire**
1824
Watercolour
160 × 225 ($6\frac{5}{16}$ × $8\frac{7}{8}$)
Watermarked: [WH]ATMAN/[TURKE]Y
MILLS/[1]823
Turner Bequest; CCVIII M
D18146
W741

The ruined Cistercian abbey at Kirkstall had been the subject of a number of picturesque views and studies by Turner after a visit there on his 1797 tour of northern England (W224, 234, 235). For this watercolour he revisited the abbey in 1824 while staying with Walter Fawkes at Farnley Hall. The visit lasted from 19 November to 14 December, and during that time the artist made a pencil composition connected with this subject in the *Brighton and Arundel* sketchbook (TB CCX f.48), which he had also used for the view of Arundel (cat.no.14). Both this watercolour and another view of Kirkstall, showing the lock on the Leeds and Liverpool canal which runs close to the River Aire (TB CCVIII L; W745), were probably made while at Farnley, for Cooke's account books for 15 January 1825 record a payment to Turner for the loan of this view while it was engraved by John Bromley. This was to prove Turner's last visit to Farnley, for on 25 October 1825 Fawkes died aged fifty-six. After this Turner refused all invitations of hospitality from the rest of the Fawkes family.

Turner's two contrasting watercolours of the abbey brought the total number of Kirkstall views included in the *Rivers of England* series to three, as a watercolour by Thomas Girtin of this scene was also included. In contrast to the implied industrialisation of his view of the lock, this watercolour dwells with all Claude's lyricism on the pastoral quiet of the abbey. The trees in

the foreground are absent from Turner's pencil sketch of the scene, made in winter; here they contribute to the mood of late summer lushness.

16 River Scenery
London, 1827
Open at pp.2–3: 'Stangate Creek, on the River Medway'
Engraving by Thomas Lupton after Turner, later state on india paper (R 766): 335 × 262 ($13\frac{1}{4}$ × $10\frac{1}{4}$)
Engraved inscriptions: below, with title, names of artist and engraver and 'RIVER SCENERY, PLATE 1/London. Published March 1, 1817, by W.B. Cooke, 9 Soho Square'
Tate Gallery Library

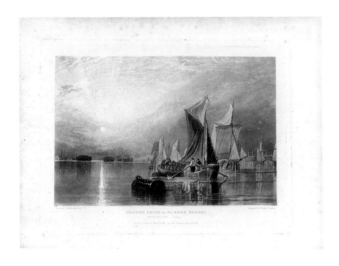

The plates for the *Rivers of England* were published between 1823 and 1827. In format the publication resembled the *Picturesque Views on the Southern Coast* and advertised itself as a companion, 'presenting a series of picturesque delineations of the *interior* of the country, while the former display the most prominent features of its shore'. Each number contained three views, which could be purchased in a wrapper for 10s or as individual proofs, at 14s for Imperial proofs, and 16s for proofs on india paper. The final part included an accompanying text for each plate by Mrs Hofland (who had also contributed text to the *Southern Coast* publication). This text could be bound up into one volume, following instructions, and from 1827 the engravings were available in a volume as a bound set.

The original scheme for the publication was expansive, including thirty-six subjects, but by 1826 its scope had been curtailed from twelve numbers to seven, and only twenty-one subjects were ever published. There were initial problems with the engraving process, which used the newly introduced steel plates, and three subjects had to be cancelled because of badly prepared plates.

Cooke employed a team of six engravers, four of whom had worked previously with Turner on his *Liber Studiorum*. Turner's watercolours were executed to a size almost exactly that of the plate onto which they were to be translated into mezzotint. In contrast with designs for the line engravings in the *Southern Coast*, this series seems to acknowledge the broader tonal capabilities of mezzotint: Turner includes more painterly inventions such as the delicate forms of cloud movement and the subtle textures of vegetation. Unlike the watercolours for the *Southern Coast* which Cooke bought from Turner at between £7 10s and ten guineas each, Turner kept all but one of the *Rivers* watercolours (W 742), loaning them at 8s 8d each. As well as subjects by Turner the publication included four views after Thomas Girtin (Kirkstall, Ripon, York, and Bolton Abbey; a fifth subject of Durham was promised) and one by William Collins (Eton; another view on the River Brent was advertised in 1824 as in preparation).

Cooke had employed Turner in 1822 to touch the proofs of Thomas Lupton's mezzotint of Girtin's 'White House at Chelsea', and seems also to have paid Turner to touch Girtin's views for the *Rivers*; Turner performing this task with a certain degree of compassion for his dead fellow artist.

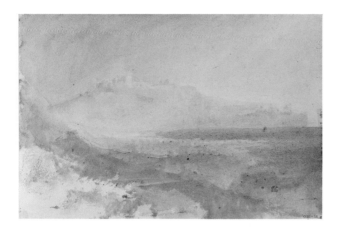

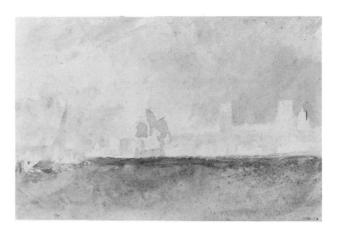

Ports of England sketchbook *c.*1822–4

17 **Dover Castle from Shakespeare Cliff**
Watercolour
178 × 258 (7 × 10⅛)
Watermarked: J WHATMAN/1815
Turner Bequest; CCII f.18
D17737

This sketchbook, which Turner seems to have used around 1822 in conjunction with a journey along the southern coast of England, contains twenty-two watercolour studies similar to this opening. Other subjects depict Folkestone and Portsmouth, but the majority focus on the cliffs at Dover. For example, f.14 relates to the view of the sea in the *Ports of England* watercolour (cat.no.20) of about 1825. Another view, on f.16, is taken from the east cliff close to the castle looking back over the town, with the peak of Shakespeare Cliff seen beyond the harbour. A separate colour study of the subject suggests the possibility that Turner contemplated making a larger watercolour of this view (TB CCLXIII 186).

The watercolour on this opening, previously exhibited as a study for the *Ports of England* view of 'Scarborough' (cat.no.21), and another watercolour on f.13, were made as preparatory stages in the design of 'Dover, from Shakespeare Cliff' (W 483), which was engraved by George Cooke on 6 May 1826 as the penultimate plate for the *Southern Coast* (R 126). The viewpoint is the earthworks below Shakespeare Cliff, built to defend the coast against the threat of Napoleonic military aggression. The castle, for the most part, is barely distinguished from the colours of the east cliff and is chiefly defined by its blue shadows. Turner was able to use such economic means to delineate the castle because he was already thoroughly familiar with its details; in the *Folkestone* sketchbook of 1821–2 (TB CXCVIII), for example, he had made extensive drawings of the fortification.

18 **Study for 'Portsmouth'** *c.*1823–4
Watercolour and pencil
165 × 249 (6½ × 9¹³⁄₁₆)
Turner Bequest; CCIII A
D17758

Several of the *Ports of England* watercolours have related studies such as this, in which Turner assembles the principal features of the view as an almost diagrammatic colour structure, and then experiments with the drama implied by contrasting rhythms of juxtaposed ships and curling waves. Other examples are the studies of Ramsgate (TB CCLXIII 299) and Sheerness (TB CCLXIII 266).

The slanting sunlight so characteristic of the finished watercolour of Portsmouth (cat.no.19) is already suggested here as an intrinsic part of the composition, as is the man-of-war, although this is not yet the dominant focus. One important change between this and cat.no.19 is the moving of the yacht on the left to the other side of the composition giving greater emphasis to the central semaphore tower, which still requires definition in this sketch.

A watercolour on f.6 of the *Ports of England* sketchbook (cat.no.17) shows the view looking out from Portsmouth harbour, and it is possible that this sheet may have been taken from that book.

The verso of this sheet has a watercolour sketch of the coast at Brighton looking along to the Old Chain Pier which was built in 1823 (see cat.no.60).

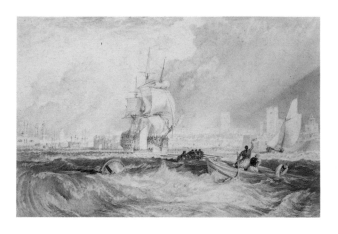

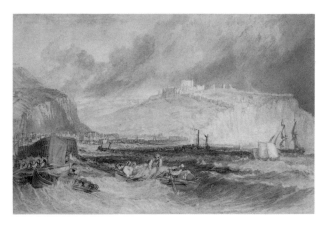

19 **Portsmouth** *c.*1824-5
Watercolour
160 × 240 ($6\frac{5}{16}$ × $9\frac{7}{16}$)
Turner Bequest; CCVIII s
D18152
W 756

While the *Rivers of England* was still in production, the engraver Thomas Lupton and Turner embarked on a similar series of mezzotint marine views initially referred to as the 'Harbours of England'. Turner gave the project this name on a vignette design which served as the wrapper illustration for the publication (W 750; R 778). An advertisement in May 1826 for what was announced as the *Ports of England* set out its intended scope of 'Twelve Numbers to form a Volume' – each number containing two plates. However, Turner produced fourteen views of what should have been a group of twenty-four. The costs were 8s 6d for each number, while proofs could be had separately at 12s 6d or 14s for the finer india paper proofs. Only three parts appeared (a fourth was in hand), the project reaching a kind of completion in 1856 when Lupton collaborated with John Ruskin to produce a set of twelve plates published as *The Harbours of England* (Ruskin, *Works*, vol.XIII, pp.1–76).

Turner made a number of pencil sketches of Portsmouth harbour and the crowded shipping there in his *Old London Bridge and Portsmouth* and *Gosport* sketchbooks (cat.no.30 and TB CCVI). As cat.no.17 demonstrates, Turner was well provided with unused material which he had gathered in connection with the *Southern Coast*. Indeed, a similar view of Portsmouth is to be found in that publication (W 477; R 120). A third finished watercolour of Portsmouth was engraved for the *England and Wales* series in 1831 (W 828; R 252). The excitement of this scene is focused on the waving sailor in the foreground, and the drama is heightened by the tonal movement of the storm clouds from left to right.

20 **Dover*** *c.*1825
Watercolour
161 × 245 ($5\frac{5}{16}$ × $9\frac{5}{8}$)
Turner Bequest; CCVIII U
D18154
W 753

The basis for this watercolour is a colour study in the *Ports of England* sketchbook (TB CCII f.14). This view is the third finished watercolour of the town that Turner had made since 1822, and was preceded by a similar large-scale composition for the *Marine Views* (cat.no.7) and another view, taken further to the west of the town at Shakespeare Cliff, for the *Southern Coast* (see cat.no.17).

Every aspect, both traditional and modern, of the life of the port is suggested, embracing the smallest lobster fisherman and his craft, the ruins of a vessel on the shore, the new paddle-steamboat and the brig on the right. Ruskin complained that in this watercolour Turner had dwarfed the town by making the cliff at the left seem higher and more precipitous than in reality. As in most of Turner's views of Dover, the castle dominates the composition, its walls extending to the edge of the cliff, the keep brightly illuminated against the dark of the surrounding storm clouds.

Even though Turner had made many sketches of the castle he clearly still found much to observe, and in all his sketchbooks to the end of his career it remained a favourite subject. At about the same time as this watercolour Turner travelled from Dover to the Continent on a tour of the Low Countries (see cat.no.43) and made detailed pencil sketches of the familiar harbour whilst waiting for his crossing (TB CCXV ff.3 verso, 4, 4 verso and 5).

The verso of this sheet is inscribed with a list of what appears to be Turner's expenses on a journey through Kent:

& Gˢ _____		2.6
[Fol]kstone		5
[D]eal		4
[Sandw]ich		4
ou Bill	1	5
[Can]terby		9
Bill		5
[Whi]tstable _____		5
[Faver]sham _____		5
[C]oach to London	1	10
	5	10

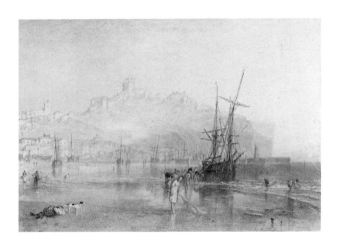

21 **Scarborough** *c.*1825
Watercolour over traces of pencil
157 × 225 ($6\frac{3}{16}$ × $8\frac{7}{8}$)
Turner Bequest; CCVIII I
D18142
W 751

Of the six *Ports of England* subjects published as mezzo-tints during the 1820s this is the only view taken from the safety of the shoreline. The soft morning light here is reminiscent of a watercolour of Scarborough made by Turner in 1811 for Walter Fawkes (w 528), which also includes a cutter unloading its wares into horse-drawn carts in the surf. The town was the focus of a large fishing fleet, seen in the distant harbour, and the activity of the figures in this subject testifies to the livelihood the sea provided. On the sands between the girl shrimping and her dog lies a starfish, a feature which, as Ruskin noticed, Turner included in all his finished views of Scarborough. Although the details of the town are instantly recognisable, Turner is not simply concerned with recording topography. The view is more an atmospheric study of the calm of morning, evoked through the tranquil glow of the whole scene and in details such as the mist settled between the hills of the church and castle.

22 **Study for 'Bridge and Monument'** *c.*1820–5
Pencil and watercolour (faded from exposure to light)
183 × 276 ($7\frac{3}{8}$ × $10\frac{13}{16}$)
Turner Bequest; CXCVII C
D17193
W 776 (incorrectly listed as TB CCLXIII 252)

After the *Liber Studiorum* project came to an end in 1819, only seventy-one subjects of Turner's planned hundred designs had been published. Although not related to any particular published project there are twelve mezzotints which form the group usually called (for want of a better name) the 'Little Liber'. The plates for these were, as far as is known, scraped by Turner himself. This sheet is one of a number in the Turner Bequest related to this group of mezzotints (see also cat.no.24).

Several factors seem to have contributed to a renewal of his interest in the techniques and capabilities of mezzotint. The first was his participation in 1822 in touching the proofs of Thomas Lupton's mezzotint after Thomas Girtin's 'White House at Chelsea' (see also cat.no.16). Secondly, there was his involvement in the production of the mezzotints for the *Rivers of England* from 1823.

The title given to the mezzotint of this subject – 'Bridge and Monument' – was first attached by Rawlinson in 1908, since Turner left no indication of his titles other than a list inside the cover of the *Worcester and Shrewsbury* sketchbook (TB CCXXXIX). However, comparison of this watercolour with the mezzotint suggests that the solid form on the right is not an arched bridge, but the reflected disc of the moon under a mass of clouds. The 'monument' in the centre of the composition becomes easier to read as a kind of lighthouse, similar to that of Shields (see cat.no.12), or as a monument like that in Turner's watercolour of 'Yarmouth Sands' (w 904); the grey shape on the left may

then be identified as a ship's hulk. The composition is perhaps not among the most dramatic of the 'Little Liber', being more a study of obscured light, but is interesting for the introduction of a viewpoint which includes both the setting sun and the moon seen behind clouds, an effect also found in cat.no.25.

The sheet of paper on which this drawing is made bears the faintest impression of a plate mark, a feature also to be found on the watercolour 'Shields Lighthouse' (TB CCLXIII 308; W 771).

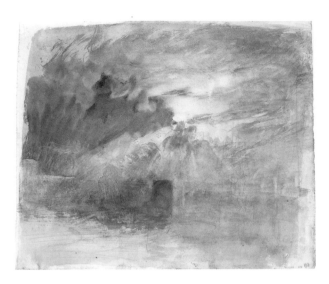

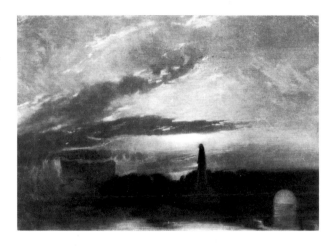

23 **Bridge and Monument** *c.*1825
148×213 $(5\frac{15}{16} \times 8\frac{5}{16})$
Mezzotint, trial proof (b)
Trustees of the British Museum, London
(1912-10-14-8)
R 807

This is one of twelve 'Little Liber' subjects printed in small numbers by Turner himself. Very much experimental in character, Turner relished the opportunity to explore the possibilities of mezzotint, the form of printmaking most closely comparable to the painterly technique of working up to highlights from a dark ground. Several of the plates for the 'Little Liber' were made from the newly introduced steel, and it is possible that Turner was producing these prints as a means of comparing the different printing capabilities of steel and copper. Most of the 'Little Liber' subjects exist in several states, recording the progress of Turner's work upon each image. This subject exists in only two known states, this being the second in which he has considerably modified the brightness of the clouds to produce a more subdued effect.

24 **The Moon behind Clouds: study for 'Shields Lighthouse'*** *c.*1823-5
Watercolour, with pencil
262×314 $(10\frac{5}{16} \times 12\frac{3}{8})$
Turner Bequest; CCLXIII 192
D25314

This study is similar in colour and technique to one of the 'Little Liber' subjects, 'Shields Lighthouse' (TB CCLXIII 308; W 771). The form on the left resembling the lighthouse shown in the distance in the *Rivers of England* view (cat.no.12), along with the inclusion of a tall sailing ship with its sails unfurled added in pencil may suggest that Turner worked on all three designs at roughly the same time. The pencil ship here is a similar annotation to that in the 'Little Liber' subject, 'Ship in a Storm' (TB CCLXIII 309(a); W 772), where Turner has apparently worked primarily on the effect of the swirling wave, only adding the pencil ship afterwards.

This design may have also contributed to the 'Little Liber' mezzotint of Shields in which the final state shows the moon almost obscured by clouds, although the original watercolour and the early stages of the mezzotint show it surrounded by a halo of light.

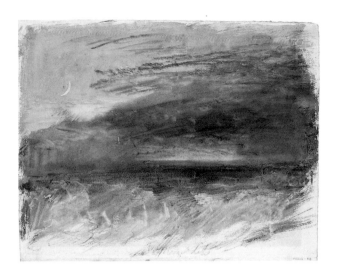

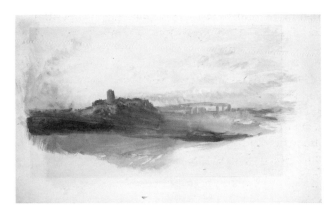

25 St Michael's Mount *c.*1823–5
Watercolour and some pencil (faded from exposure to light)
241 × 303 ($9\frac{1}{2}$ × $11\frac{15}{16}$)
Inscribed in pencil along the bottom edge, 'Moon Lits'
Turner Bequest; CCLXIII 311
D25434

This watercolour relates to the 'Little Liber' mezzotint 'St Michael's Mount', produced by Turner in the 1820s (R 802). He had made a detailed watercolour of St Michael's Mount probably in 1812 for the *Southern Coast* project (W 445; R 88) based on pencil drawings in the *Ivy Bridge and Penzance* sketchbook (TB CXXV ff.43 verso, 44), and was to return to the subject for an oil painting exhibited at the Royal Academy in 1834 (B & J 358) and a watercolour engraved for the *Picturesque Views in England and Wales* (W 880; R 304).

St Michael's Mount itself does not appear in this watercolour, the title alluding to one of the unfinished trial proofs on which Turner has added the mount in a pencil annotation. Unlike other similarly annotated mezzotints, such as that of 'Paestum' in the British Museum (1916-6-14-3) which gained its second temple through this kind of revision, the detail of the Mount was not added to the plate which was discovered completely corroded at Turner's death.

In an effect similar to that deployed in other watercolours for 'Little Liber' subjects, Turner differentiates between the varied types of lighting with the cool dark night surrounding the crescent moon, while at the centre of the design the last embers of the sun are spread across the approaching storm clouds over the sea.

26 Tower on a Hill at Sunrise *c.*1825–7
Watercolour (the image outlined in pencil and faded from exposure)
302 × 482 ($11\frac{7}{8}$ × 19)
Watermarked: T EDMONDS/1825
Turner Bequest; CCLXIII 325
D25448

The scene of this watercolour has so far evaded identification, but its technique is similar in colouring and the resulting mood to the watercolours made in conjunction with the 'Little Liber' mezzotints, if perhaps made at a slightly later date. The silhouetting of the tower is reminiscent of 'Norham Castle' (cat.no.10), and points to an underlying habit in Turner's compositions to seek the *contre-jour* effect to heighten the contrast with the skies depicted.

This watercolour was selected by R. N. Wornum, the keeper of the National Gallery, in 1857 as part of the Second Loan Collection, a group of watercolours which travelled around the country in the late nineteenth century beginning at Edinburgh in 1869. The pencil lines around the design were added to indicate the size of the window mount when the drawing was framed.

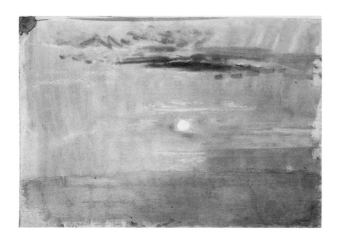 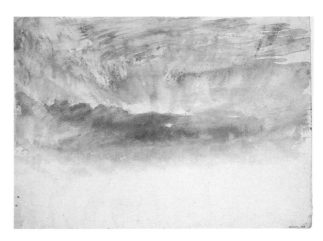

27 **Sunset over Water** *c.*1825–7
Watercolour
245 × 346 ($9\frac{5}{8}$ × $13\frac{5}{8}$)
Turner Bequest; CCLXIII 210
D25332

This and cat.no.28 are part of a sunset sequence studied in the middle years of the 1820s. Here the disc of the sun appears above what seems to be a watery surface. The reddish colour of the sky leaves the source of the light pure. This feature appears in a number of other watercolours in the Turner Bequest (TB CCLXIII 64, 136, 390). Turner was especially interested in optics during this decade and explored colour theories during his lectures as Professor of Perspective at the Royal Academy.

Even as an adolescent artist he had been captivated by the changes in the appearance of the sun, observing an eclipse in one of his notebooks (TB LXXXV) in about 1804, while more recently on his journey by boat to Edinburgh in 1822 he had vividly recorded, even if only in pencil, the last stages of a sunset as the sun sank towards the horizon seeming to attach itself to the surface of the sea (TB CC ff.2 verso, 3).

28 **Fiery Sunset*** *c.*1825–7
Watercolour
246 × 348 ($9\frac{11}{16}$ × $13\frac{11}{16}$)
Watermarked: J WHATMAN / TURKEY MILLS / 1823
Turner Bequest; CCLXIII 208
D25330

While Constable is well known for his studies of clouds made during the 1820s, many pages in Turner's notebooks record this kind of subject as an ever-present concern of his work, if not pursued with Constable's scientific rigour. In 1856 Ruskin wrote that the scientific delineation of 'the aspects of sunset and sunrise, with all their attendant phenomena of cloud and mist' was a central obsession in contemporary art, no doubt influenced by his involvement with Turner's work (Ruskin, *Works*, vol. V, pp.317–8). The engraver John Burnet noticed that in Turner's work 'the colour of clouds was always founded upon the basis of chiaroscuro; hence the change into black and white engravings is less injurious to the effect than in the case of other artists' (John Burnet, *Art Journal*, 1852, p.48, quoted in Gage 1987, p.76).

29 Study of a Sunset Sky 1825–30
Watercolour
302 × 439 ($11\frac{7}{8}$ × $17\frac{1}{4}$)
Turner Bequest; CCLXIII 137
D25259

It is easy to see from studies such as this and cat.nos.27 and 28 how Turner was able to recreate in projects such as the *Rivers of England* and the *Picturesque Views in England and Wales* the effects of clouded skies. During the 1820s he seems to have made this a particular area for study, and there are sheets containing two, three and sometimes four cloud studies (see TB CCLXIII 115, 119, 122). The broad washes of this sheet contrast with what appear to be feathery brush strokes used to differentiate the subtlety of colour across individual clouds.

Several of the watercolours exhibited here (cat.nos.29, 31 and 41) were grouped into a parcel of twenty sheets by John Ruskin when he was engaged in selecting watercolours to display at the National Gallery, and which he designated 'Colour effects. finer'. These were presumably finer than many of the other unfinished private studies which he considered 'valueless'.

Old London Bridge sketchbook
c.1823–4

30 Studies of London Bridge and the River Skyline: Monochrome Study of a Sunset
Pencil and grey wash
103 × 167 ($4\frac{1}{16}$ × $6\frac{9}{16}$)
Watermarked: ELL's/1821
Turner Bequest; CCV ff.20 verso, 21
D17873, D17874

A proliferation of illustrated publications on London in the early 1820s seems to have encouraged Turner to execute his own watercolours for a project instigated by W.B. Cooke. Four finished watercolours are known: 'View of London from Greenwich' (W 513); 'Old London Bridge and Vicinity' (W 514); 'The Tower of London' (W 515); and 'The Custom House' (W 516, see also cat.no.31). The pencil sketches on the left-hand page of this opening relate to details of the watercolour of 'Old London Bridge and Vicinity' now in the Victoria and Albert Museum. Other details are recorded on f.9 verso and f.10, which also have paint splashes, suggesting that Turner referred to the sketches while actually working on his watercolour. The structure of that watercolour is also worked out in a colour study (TB CCLXIII 169.

The right-hand sheet is one of several monochrome studies, primarily of clouded sunsets, in this book. It appears that Turner was experimenting with the technique of conveying a coloured effect in black and white, for it and other watercolours of the period relate very closely to the preoccupations behind the series of mezzotints known as the 'Little Liber' (see cat.nos.22–25).

Another pencil drawing, on f.44, is a hastily scribbled reminder or copy of Ruben's painting 'Le Chapeau de Paille', which could be seen at Mr Stanley's Rooms in Bond Street between March and June 1823, where it was acquired by Robert Peel.

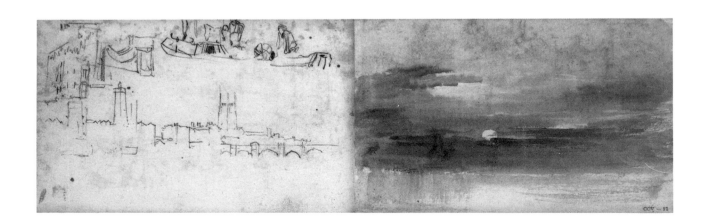

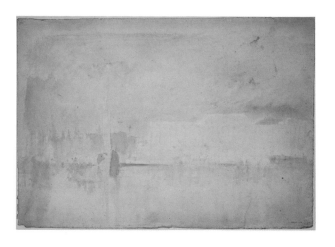

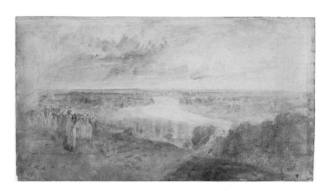

31 The Custom House from the River *c.*1825
Watercolour
353 × 488 (13$\frac{7}{8}$ × 19$\frac{1}{4}$)
Turner Bequest; CCLXIII 100
D25222

This watercolour shows the now demolished Custom House, rebuilt in 1812–17 by David Laing and expanded on the river front in 1825 by Sir Robert Smirke. Smirke was a friend of Turner's and it may have been this fact which led to the artist making a finished watercolour of the building, engraved in 1827 and related to his proposed series of London views (w 516; see cat.no.30). The Turner Bequest contains two smaller watercolours which relate much more closely to the angle of the finished view, in which the building is seen from a point close to the shore at the right-hand side, with the dome of St Paul's suggested above the forest of ships' masts (TB CCLXIII 227 and 255). This watercolour relates to pencil and sepia sketches of the river in the *Tabley No.3* sketchbook (TB CV) and the *Scotland and London Bridge* sketchbook (TB CLXX).

32 The Thames from Richmond Hill: preparatory study *c.*1823–5
Watercolour and pencil
320 × 540 (12$\frac{5}{8}$ × 21$\frac{1}{4}$)
Watermarked: B.E. & S./1823
Turner Bequest; CCLXIII 348
D25471

This viewpoint was easily accessible to Turner from his home at Sandycombe Lodge until 1826 when he sold the house. Even before the time of his residence at Twickenham the view had been familiar to him, and was to inspire watercolours such as those made for the *Picturesque Views in England and Wales* (w 833 and w 879) as well as the oil painting depicting the Prince Regent's birthday in 1819 (see B & J 140; Gallery 108). In the mid-1820s Turner was involved with the production of illustrations for the annual pocket-books produced by rival publishers each Christmas. This watercolour anticipates an illustration made for the *Literary Souvenir* (w 518; R 314), and engraved in 1826 by Edward Goodall. As well as a boy preparing to fly his kite, the final version contains various genteel figures including several ladies with their parasols – a feature which is already suggested in this watercolour by the halo-like forms around the figures on the left. On the right of the sketch Turner has indicated in pencil the outline of trees, which only appear in the later watercolour of Richmond Terrace made for the *Picturesque Views in England and Wales* (w 879).

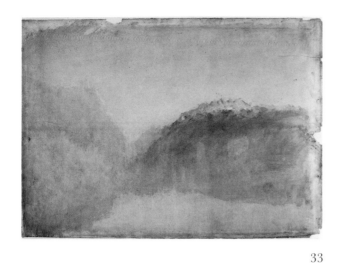

33

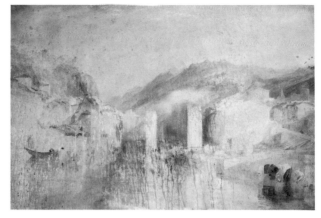

34A

33A

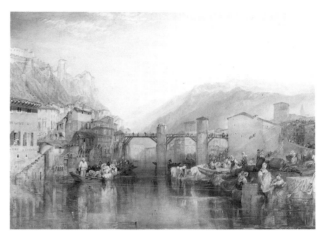

34B

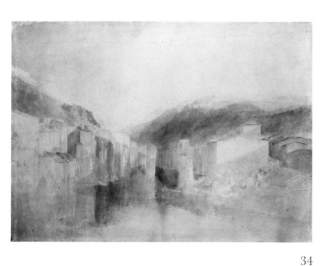

34

33 **Grenoble Bridge; preparatory study**
 *c.*1825
 Watercolour with some stopping and scratching-
 out
 554 × 767 (21½ × 28½)
 Watermarked: J WHATMAN/TURKEY MILLS/ 1825
 Inscribed in pencil, top right, 'P Mag'
 Turner Bequest; CCLXIII 391 (add)
 [*Note:* This may be the drawing TB CCLXIII 345,
 listed as missing, but which resembles the general
 description of this drawing including watermark]
 D25515

33A **Grenoble Bridge: preparatory study** [not
 exhibited] *c.*1824
 Watercolour
 504 × 711 (19¾ × 28)
 Turner Bequest; CCLXIII 368
 D25491

34 **Grenoble Bridge: preparatory study*** *c*.1824
Watercolour with stopping-out and some pencil
underdrawing 555 × 750
Watermarked: B.E. & S./1823
Turner Bequest; CCLXIII 346
D25469

34A **Grenoble Bridge: preparatory study** [not
exibited] *c*.1824
Watercolour
474 × 692 ($18\frac{11}{16}$ × $27\frac{1}{4}$)
Turner Bequest; CCLXIII 367
D25490

34B **Grenoble Bridge** [not exhibited] *c*.1824
Pen and black ink, watercolour and bodycolour,
with heightening in white ink
530 × 717 ($20\frac{7}{8}$ × $28\frac{1}{4}$)
Inscribed: JMWT
W 404
Baltimore Museum of Art, Maryland (68.28)

These sheets are two of four preparatory studies for a
watercolour of the bridge over the River Isère at
Grenoble, commissioned by a Charles Holford. Almost
nothing is known of Holford, except that he lived in
Hampstead, and the view of 'Grenoble Bridge' (W 404)
(now in Baltimore) appears to be the only work by
Turner he acquired.

According to a note in an 1872 Christie's sale
catalogue when the watercolour was sold for the second
time, the finished view was made in 1824. Two of the
colour studies and the finished watercolour itself bear
the watermark of the papermakers Bally Ellen and
Steart for 1823 which would support this suggestion.
However cat.no.33 has a watermark of 1825 on What-
man paper. This would suggest that Turner may have
either executed the watercolour in 1824 based on three
studies (cat nos.33A, 34, 34A) and contemplated in
cat.no.33 producing another version of the same sub-
ject, or that the paper of cat.no.33 was manufactured in
1824 but its later watermark was introduced for the
Indian market in anticipation of its arriving there in
1825.

Turner had visited Grenoble in 1802 on his first visit
to the Continent. While in the area of the town he made
a number of pencil and chalk sketches on pieces of
brown paper. During the 1820s he utilised subjects from
this group for the basic topographical detail in his
vignette designs for Rogers's *Italy* ('Martigny',
TB CCLXXX 154; 'Aosta', cat.no.52).

Two of the 1802 sketches of Grenoble show the town's
bridge from the river (TB LXXIV 14, stamped A;
TB LXXIV 14a, stamped X). The former of these is the
primary source for the composition of this view, modi-
fied only by moving the viewpoint slightly over towards
the right shore. The height of various buildings in-
creases in the later watercolour as well as the details of
the Fort de la Bastille on the top of the left-hand cliff.

In the group of colour studies Turner's working
practice can followed stage-by-stage towards the fin-
ished work. Cat.no.33 represents the most basic stage of
the view, with its broad tonal areas of orange, blue and
yellow (slightly faded after being exhibited in the
nineteenth century), the most suggestive detail being
the white patches of mountain snow. The circular patch
of orange on the lower right-hand side seems not to be
the suggestion of a reflected sun, as this feature does not
appear in the final work, but may possibly relate to the
colour of the clothes being washed in the finished
subject.

The second study (cat.no.33A) introduces much
more of the structure: the piers of the bridge and its
surrounding houses, and the suggestion of boats and
figures. In cat.no.34, the design becomes more concrete
with distinctions made between the outlines of houses
and their terracotta roof-tiles, as well as introducing the
slanting effect of shadows. The magical blue heights of
the distant mountains and their reflections here antici-
pate more precisely the final design – only omitting the
central block of white peaks. The introduction of figures
in a boat by means of stopping-out (a technique Turner
had used a great deal in his youth; see also cat.no.9)
suggests the meeting point on the water of the forms and
their reflections. The final study has unfortunately been
damaged by water (cat.no.34A), possibly during
Turner's lifetime, but it is still possible to see the
progress he was making towards the completed design.
At the lower right corner are indications of the women
washing clothes in the river. The finished watercolour
(cat.no.34B) seems to incorporate anticipated changes
to the appearance of the real view between 1802 and
1824; for where Turner had only shown a low stump for
the left-hand tower of the bridge in 1802, the final
watercolour includes a group of workmen apparently
finishing the tower. It is in this kind of picturesque detail
of the daily lives of people that Turner transforms the
raw material of a pencil sketch into a fully-fledged work
of art.

Norfolk, Suffolk and Essex sketchbook 1824

35 **Two Views of the Church of St Peter and St Paul, Aldborough (from the North-East and the South-West): Two Views of Aldborough from the Harbour**
Pencil, with a blue paint splash
115 × 188 (4½ × 7½)
Watermarked: ALLEE/1819
Turner Bequest; CCIX ff.56 verso, 57
D18267, D18268

In 1824 Turner travelled north from London to visit Walter Fawkes, passing through Essex, Norfolk and Suffolk on his journey. His choice of this route was no doubt influenced by his work on the proposed continuation of the *Coast* project up the east side of England (see cat.no.59). However, once he began to make watercolours for the *Picturesque Views in England and Wales* venture in the following year, this sketchbook provided subject matter for drawings of Colchester (W 789), Great Yarmouth (W 810), Lowestoft (W 869), Orford (W 796) as well as Aldborough (now Aldeburgh).

Both sides of this opening can be related to the finished watercolour of 'Aldborough, Suffolk' included in the *Picturesque Views in England and Wales* (cat.no.36). The church in the two sketches on the left-hand page is that of St Peter and St Paul, which is seen here in a partly ruined condition prior to restorations over the last century and a half. It appears on the horizon of the finished view behind the group of masts. The right-hand sheet includes the Slaughden Martello tower, larger than most towers of this sort, which becomes such a distinctive part of the final design. Martello towers were built in the period 1810-12 as part of the coastal defence system against Napoleon's threatened invasion. Turner had also shown a view of the Martello towers on the southern coast at Bexhill in one of his *Liber Studiorum* designs (RL 34).

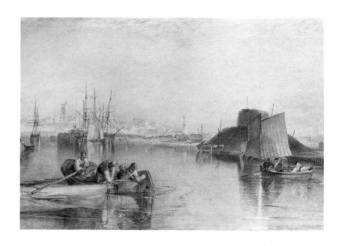

36 **Aldborough, Suffolk** *c.*1826
Watercolour and bodycolour
280 × 400 (11 × 15¾)
N05236
W 795

The engraving of 'Aldborough' by Edward Goodall (1795-1870) based on this watercolour was published in the third part of the *England and Wales* project in December 1827. Turner had visited and sketched the town in 1824 (TB CCIX ff.57 verso, 58, 59; see cat.no.35).

This is one of Turner's most evocative treatments of dawn; he has scratched the paint off the paper above the Martello tower to suggest the rising sunlight. He was to paint Aldborough again during the next year or so as one of the group of watercolours for the *East Coast* project (W 899). In both subjects Turner encapsulates the maritime economy of the town, here focusing our attention on the three men mending a floating mast.

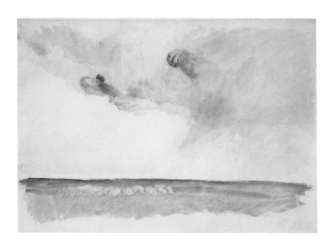

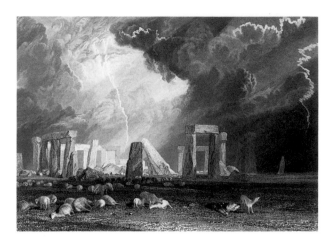

37 **Stonehenge: preparatory study** *c.*1826–7
Watercolour, with pencil outlines
346 × 488 (13⅜ × 19³⁄₁₆)
Inscribed in pencil, lower edge, 'Stonehenge No.1
No.2 done'
Turner Bequest; CCLXIII 1
D25123

While the Turner Bequest contains none of the finished watercolours engraved for the *Picturesque Views in England and Wales* it does contain many studies which are preliminary stages for *England and Wales* designs. Even if the inscription on this sheet did not indicate that its subject was Stonehenge, comparison with the finished watercolour or engraving would suggest that it has some connection with that design, particularly in the suggested vortex of cloud. On the basis of the colours used here and in the finished watercolour, another study can be associated with Stonehenge (TB CCLXIII 37), which is perhaps the 'No.2 done' referred to in the inscription on this sheet.

Turner had made several sketches of Stonehenge, having visited the site between 1799 and 1802 (*Studies for Pictures* sketchbook, TB LXIX ff.79, 80 verso) and again around 1811–15 (*Devonshire Coast* sketchbook, TB CXIII ff.211, 212, and the *Stonehenge* sketchbook, TB CXXV(b)). The ancient stones, suggested merely in faint pencil outlines on this sheet, had also served as the subject of one of the unpublished *Liber Studiorum* subjects (RL81), possibly made in the early 1820s.

R. WALLIS (1794–1878) after J.M.W.TURNER

38 **Stone Henge** 1829
for *Picturesque Views in England and Wales*
Engraving, first published state on india paper
R235: image size 166 × 234 (6½ × 9³⁄₁₆); on india
paper laid on wove paper 425 × 592 (16¾ × 23¼);
plate mark obscured by india paper
T04549

Robert Wallis was responsible for the engraving of twelve of the ninety-six *England and Wales* plates, and also worked on Turner's designs for the *Southern Coast* and Rogers's *Italy* (see cat.nos.52–57).

This engraving was published in the seventh instalment of the *Picturesque Views in England and Wales* along with views of Louth (W809; R233), Great Yarmouth (W810; R234) and Hampton Court Palace (W812; R236). To coincide with the publication of this group of prints, Charles Heath held an exhibition in June 1829 at the Egyptian Hall in Piccadilly. As well as the prints, the exhibition included a number of the original watercolours, one of which was that of Stonehenge (W811). The work was also shown at the Birmingham Society of Artists in the autumn of that year, after which it entered the collection of the poet Samuel Rogers, then involved in the final stages of his publication *Italy*, for which Turner had provided designs.

The finished watercolour is 279 × 404 mm, approximately twice as big as this engraving, although generally for other projects in this decade Turner's watercolours approximate to the size of the plates they were to be engraved on.

The moment of this scene follows the passing of the centre of a storm. A bolt of lightning, still evident, has just killed the shepherd as well as several of his sheep.

39 **Alnwick Castle, Northumberland** 1830
for *Picturesque Views in England and Wales*
Engraving, first published state on india paper
R 242: image size 166 × 243 ($6\frac{9}{16}$ × $9\frac{9}{16}$); on india
paper laid on wove paper 440 × 613 ($17\frac{5}{16}$ × $24\frac{1}{8}$);
plate mark 255 × 316 (10 × $12\frac{3}{8}$)
T05084

Alnwick Castle is the family home of the Earls of
Northumberland. During the late eighteenth century it
had been greatly altered in the Gothic fashion by
Robert Adam, before being redecorated in the mid-
nineteenth century by Anthony Salvin.

For the majority of the early *England and Wales*
designs Turner utilised pencil drawings from earlier
journeys, only specifically tailoring his travels to the
needs of the project in a tour of the Midlands in 1830.
This design originates from a pencil sketch in his 1797
North of England sketchbook (TB XXXIV f.44). The
architecture is arranged almost identically in both
images, the most marked change being the introduction
of a wider gap between the main keep and the postern
tower to reveal the moon. In the pencil drawing of the
bridge Turner only partially indicates the decorated
relief on the parapet and shows just two arches; this
helps to explain the slightly distorted curve of the three
arches seen in this engraving. The Lion Bridge over the
River Alne was built in 1773 by John Adam; the statue
of the lion after which it is named can be seen as a black
silhouette on the parapet immediately below the moon.
Nothing in the pencil sketch suggests that Turner
viewed the scene by moonlight, although he does
indicate a stillness on the river by the inclusion of
reflections of the castle, an effect recreated here and only
broken by the evidence of fish breaking the surface.

James Willmore has used the softer metal of the
copper plate upon which the image was engraved to
convey the delicacy of the clouded moonlight. The
watercolour for this subject (w 818; now in Australia)
was one of those exhibited at the Egyptian Hall in 1829
(see also cat.no.38).

40 **A Scene on the Thames: ?Garrick's Villa and
the Temple to Shakespeare at Hampton**
*c.*1825–8
Watercolour
355 × 507 (14 × 20)
Turner Bequest; CCLXIII 23
D25145

This study can be stylistically associated with the
England and Wales project, although no finished water-
colour of this view is known. It relates to pencil
drawings in the *Isle of Wight* sketchbook (TB CCXXVII
ff.20 verso and 21 verso). The dome-like structure to the
left of the block of white on this sheet appears to be the
Temple to Shakespeare built by the actor David
Garrick adjacent to his Thames-side home, the mansion
also indicated here. The lower of two pencil drawings
on f.21 verso of the *Isle of Wight* sketchbook records a
group of trees similar to those in this view suggesting
that these trees are not merely a Claudean composition
device of the kind often deployed in Turner's Italian
views.

The *Isle of Wight* book also includes a couple of
watercolours, made on white paper prepared with a
grey wash, which are similar to this view in their
treatment of Thames scenery under cloudy summer
skies (TB CCXXVII f.5 and f.35), while a sketch of a
wooden bridge on f.40 verso was also worked up as a
preparatory watercolour (TB CCLXIII 102). Similarly
the architecture of Hampton Court Palace appears in

pencil sketches on several pages of the book, and this was one of a number of Thames subjects Turner developed for the *Picturesque Views in England and Wales*, others being views of Walton Bridges (w 824; r 248), Windsor Castle (w 829; r 253), Eton College (w 830; r 254), Richmond Hill and Bridge (w 833; r 257), and Richmond Terrace (w 879; r 303).

41 **Castle Upnor, Kent: preparatory study***
 c.1829–30
 Watercolour
 330 × 551 (13 × 21 11/16)
 Watermarked: T EDMONDS/1825
 Inscribed in pencil, top right corner, 'H Water'
 Turner Bequest; CCLXIII 124
 D25246

This watercolour has previously been understood to be a view of Flint Castle on the basis of a misreading of the pencil inscription in the top right corner as 'N Wales'. However, it seems more likely that it is a preparatory study for the watercolour of 'Castle Upnor, Kent' which Turner executed most probably either in 1829 or 1830 (w 847), and which was engraved by J.C. Allen as an *England and Wales* subject in 1833 (r 271). The overall composition is an almost exact preparation for the 'Castle Upnor' watercolour, with the sunset light surrounding the disc of the sun offset by a cooler patch of blue cloud at the right. There is also the suggestion of the hulks of various craft, and the fortifications of Chatham on the brow of the left-hand hill. Both compositions have figures, although in this preparatory study Turner provides a knoll from which they survey the river. The outline of Castle Upnor in this study is more uneven than in the finished view and relates to a pencil sketch on f.23 verso of the *Medway* sketchbook (TB CXCIX), rather than another drawing on f.87 verso and f.88, which provides the expansive panorama Turner has contracted for this view. The sketchbook

also contains careful notes of the shipping seen on the River Medway in the early 1820s, with a sketch on f.77 verso providing the details for the ship of the line which appears in the finished watercolour.

Mortlake and Pulborough sketchbook 1825

42 **Study for 'Mortlake Terrace, the Seat of William Moffatt, Esq., Summer's Evening'**
 Pencil, with some splashes of paint
 113 × 187 (4 1/2 × 7 3/8)
 Watermarked: R BARNARD/1820
 Turner Bequest, CCXIII ff. 15 verso, 16
 D18733, D18734

The drawing on this opening provided the basis for an oil painting Turner exhibited at the Royal Academy in 1827, 'Mortlake Terrace, the Seat of William Moffatt, Esq., Summer's Evening' (B & J 239, National Gallery of Art, Washington). Other drawings on pages 10 verso and 11 had been used for a companion picture the previous year (B & J 235). Like the slightly later views of Petworth Park (B & J 288, 289), this view is a reversal of the traditional topographical house portrait so that the house itself is not seen, the view from the house becoming the subject.

Holland, Meuse and Cologne sketchbook 1825

43 **View of Rotterdam: The Entrance to the Oude Haven Seen towards the River**
 Pencil
 113 × 189 (4 1/2 × 7 7/16)
 Watermarked: ALLEE/1819
 Inscribed in pencil: 'Lions Heads' beside turret of Ooster Oude Hoofdpoort, and 'B Sails [?]' over the roof of the Wester Oude Hoofdpoort.
 Turner Bequest; CCXV ff.52 verso, 53
 D19483, D19484

In August 1825 Turner began a journey through the Low Countries visiting Rotterdam, Delft, The Hague, Leyden, Amsterdam and Utrecht before travelling on to Antwerp, Ghent, Bruges and Ostend, via Cologne. Pencil drawings in this and the *Holland* sketchbook (TB CCXIV) relate to an oil painting of Cologne he was to exhibit at the Royal Academy in the following year (B & J 232). This view of the old harbour at Rotterdam shows both the Ooster and Wester Oude Hoofdpoorts of Rotterdam. Although Turner had already made a detailed pencil sketch of the Ooster Oude Hoofdpoort in 1817 in the *Dort* sketchbook (TB CLXII ff.13 verso, 14) he is meticulous in his observation here, even noting the 'lions heads' on the roof of the building.

42

43

Trèves and Rhine sketchbook ?1826

44 **View of Trier**
Watercolour, bodycolour and chalk, with pencil underdrawing on white paper prepared with a grey wash
220 × 291 (8⅝ × 11 7/16)
Watermarked: J WHATMAN/TURKEY MILL
Inscribed in pencil on f.9 verso, 'Pitner/Piffsor'

Turner Bequest; CCXVIII f.10
D20148

This sketchbook was used on a tour of the areas around the Rivers Meuse and Moselle, which is traditionally thought to have taken place in 1826, but will be redated by Cecilia Powell in her forthcoming study of Turner's work in this region. Along with the *Moselle (or Rhine)* sketchbook (TB CCXIX), this is one of the earliest 'roll' sketchbooks used by Turner on his Continental journeys. The lack of hard board covers meant that he was able to roll the book up and stow it safely in his pocket. This opening is one of four watercolours in the book, many of the leaves of which have been prepared with a grey wash similar to that in two of the sketchbooks Turner had used for coloured drawings in Rome in 1819 (TB CLXXXIX and CXC).

This view of Trier (or Trèves, as it is called in French) was one recommended to the traveller in most guidebooks, especially at the end of the afternoon when the evening light caught the town. There are several drawings of the same view in the book, as well as a number of pencil and chalk sketches of the ancient Porta Nigra in the city itself, a subject Turner worked up on blue paper (TB CCXX W).

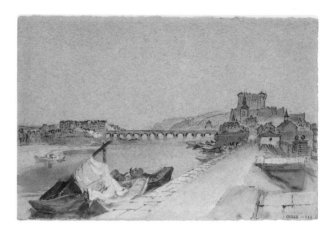

Loire, Tours, Orleans and Paris sketchbook 1826

45 **Details of the Towers and Facade of Orleans Cathedral**
Pencil
153 × 103 (6 × 4$\frac{1}{16}$)
Watermarked with a stylised bunch of grapes (probably a French paper)
Turner Bequest; CCXLIX ff.32 verso, 33
D23309, D23310

Turner travelled along the River Loire from Nantes to Orleans in 1826. Many of the pencil sketches in this and two other sketchbooks used on this journey relate to the coloured drawings worked up for the 1833 publication, *Turner's Annual Tour – the Loire*. Like the watercolour subjects of the River Seine (w 951–90), Turner originally retained the finished designs for the Loire after the engravings were produced, only choosing to sell the Loire subjects after he had negotiated with Thomas Griffith for their sale, ultimately to John Ruskin, who bequeathed the majority to the Ashmolean Museum (w 930–9, 942, 943, 945, 946, 947, 949, 950).

This drawing is typical of many in Turner's sketchbooks, where an architectural fragment has caught his eye and is scrutinised and recorded in detail. Such studies as this came in useful when completing the more finished colour designs and when advising his engravers about particular details in their work.

46 **Saumur** 1826–9
Watercolour and bodycolour with pen on blue paper
130 × 190 (5$\frac{1}{8}$ × 7$\frac{1}{2}$)
Turner Bequest; CCLIX 145
D24710
Verso: Pencil sketch of a pathway through trees.
Inscribed in pencil, top left, 'Keepsake'

There are pencil sketches of Saumur in the *Nantes, Angers and Saumur* sketchbook (TB CCXLVIII ff.42–5), but none of them is particularly close to this composition. Similarly the view of Saumur engraved for *Turner's Annual Tour – the Loire* is taken from the opposite side of the river (w 941; R 443).

There is some debate over the likely date Turner executed the group of watercolours of Loire scenery with some scholars suggesting a date after 1830 (see N. Alfrey in Paris 1981–2 exhibition catalogue, p.188). However, this drawing relates to a watercolour of Saumur (w 1046) which was engraved and published in 1830 for the 1831 *Keepsake* annual. The composition is almost identical, except that the *Keepsake* watercolour includes a great deal more staffage in the way of figures and scattered produce beside the barge moored on the left. The verso of the sheet exhibited here is inscribed 'Keepsake', perhaps by Turner, suggesting that it was selected from a group of potential subjects and its purpose recorded. It seems unlikely that Turner would have made a less detailed sketch of this view after he had already treated the same subject in such an elaborate way, suggesting a date prior to 1830 for this sheet. Since Turner worked on batches of these drawings at the same time, it is also likely that others of these Loire scenes on blue paper were made before this date, including those of Saumur (TB CCLIX 194, 201, 207).

Another argument for the earlier date is that the penwork here is reminiscent of that deployed in watercolours of about 1827, such as that of 'A Villa on the Night of a Festa di Ballo' (see cat.no.56).

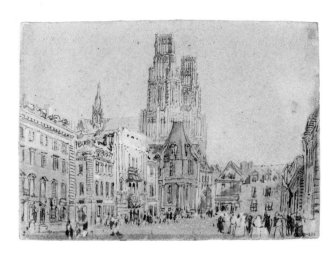

47 **Orleans Cathedral and Theatre** 1826–30
Watercolour and bodycolour with pen on blue
paper (faded in the past through exposure to light)
143 × 194 ($5\frac{5}{8}$ × $7\frac{7}{8}$)
Turner Bequest; CCLIX 199
D24764

One of the colour subjects engraved in *Turner's Annual
Tour – the Loire* (1833) was a similar view of the
cathedral at Orleans from the Place de l'Etape (W 931;
R 433). Turner visited the city in both 1826 and 1828,
the basis for both this watercolour and the engraved
subject being a pencil sketch in the *Loire, Tours, Orleans
and Paris* sketchbook of 1826 (TB CCXLIX f.34). This
view is perhaps an experiment in making the bulk of the
cathedral loom more prominently above the rooftops.
There are other coloured drawings of Orleans in the
Bequest, suggesting that Turner experimented with the
possibility of including views from the river (TB CCLIX
71). Although the drawing is much faded through
exposure to light, it nonetheless conveys Turner's skill as
an architectural draughtsman. Several of the subjects
engraved for the *Loire* series are explicitly architectural,
most notably that of St Julian's at Tours (W 939; R 441).

48 **Château of Blois*** 1826–30
Watercolour and bodycolour on blue paper
138 × 191 ($5\frac{7}{16}$ × $7\frac{1}{2}$)
Turner Bequest; CCLIX 97
D24662

There is a pencil study for this drawing in the *Loire,
Tours, Orleans and Paris* sketchbook (TB CCXLIX f.21) in
which only the minimal outline of the château is
apparent. Here Turner adds, from memory, the rich
architectural surface. He also introduces the pictur-
esque interest of the figures on the left, not found in the
original sketch. The viewpoint is the south side of the
château, beneath the Tour du Foix; the tower at
the right being that of the Cathedral of St Louis. Turner
made two views of Blois for his *Annual Tour – the Loire*:
one of the town from the river (W 933; R 435) and
another of the château (W 934; R 436). The latter view is
based on a pencil sketch on the opposite page to that
used for this drawing (TB CCXLIX f.20).

49 **Tours from the River** 1826–30
Watercolour and bodycolour, with pencil, on blue paper
139 × 191 ($5\frac{7}{16}$ × $7\frac{1}{2}$)
Turner Bequest; CCXXI W
D20256

This watercolour, formerly associated with those Turner made of scenery on the Rivers Meuse and Moselle, is a view of Tours. There is a pencil sketch for this scene in the *Loire, Tours, Orleans and Paris* sketchbook (TB CCXLIX f.10), which he has annotated with the inscription 'Saint Symphorien'. This is the Romanesque and Gothic church on the north bank of the river opposite the main town. Turner painted several colour subjects of the ecclesiastical architecture at Tours, including the church of St Julian's (W 939) and the Abbey of Marmoutier, just outside the town (TB CCLIX 18).

The composition of this drawing is similar in style to a view executed for the *Annual Tour – the Loire* called 'The Canal of the Loire and Cher, near Tours' (W 937; R 439), in which the view is taken from the river with the town visible on the left bank. In the subject on display Turner deploys a subtle watercolour and bodycolour technique, sometimes reminding himself of details by including pencil outlines, like the towers on this sheet.

50 **St Florent*** 1826–30
Watercolour and bodycolour on blue paper
144 × 193 ($5\frac{11}{16}$ × $7\frac{5}{8}$)
Turner Bequest; CCLIX 9
D24574

St Florent-le-Vieil is a riverside town on the Loire between Angers and Nantes, down river from Montjean, which Turner also painted for his *Annual Tour – the Loire* (W 943; R 445). Both this watercolour and the view of St Florent used for the engraving (W 944; R 446) are based on a group of pencil sketches on pages of the *Nantes, Angers and Saumur* sketchbook (TB CCXLVIII ff.18 and 19). The finished design exhibits rather more of the ecclesiastical buildings to the right of the central tower and includes a sandy island in the river not suggested in this view. The beginnings of a vertical line at the right of the buildings, if compared with the engraving, can be seen to be a crucifix. This study is typical of many of the soft hazy atmospheric Loire views, quite different in feeling from those made on the River Seine.

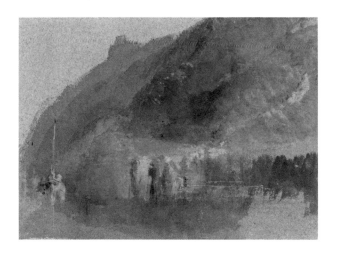

51 **Château Hamelin** 1826–30
Watercolour and bodycolour on blue paper
141×189 $(5\frac{9}{16} \times 7\frac{7}{16})$
Turner Bequest; CCLIX 98
D24663

Close to Oudon the banks of the Loire rise dramatically; on top of the cliffs at Champtoceaux are the ruins of Château Hamelin seen here. Turner observed this view from his boat and recorded the changing alignment of castle and the decayed ancient stone bridge below in a series of pencil sketches in the *Nantes, Angers, and Saumur* sketchbook (TB CCXLVIII ff.13, 13 verso, 14 and 14 verso). These notes also provided the basis for two watercolours outside the Turner Bequest: a view from a more distant point than that displayed here (W 997a); and another which reverses this view, which was engraved for the *Annual Tour – the Loire* (W 946; R 448). The verso of this sheet has a colour sketch which is possibly a preparatory study for the published view. In colouring and brushwork the sheet has something in common with those views Turner made of the lake at Petworth (see TB CCXLIV 12, 84 verso and 113); this is most marked in the treatment of reflected forms in the water.

52 **Aosta** 1826
Watercolour with some pencil
140×172 $(5\frac{1}{2} \times 6\frac{3}{4})$, vignette; 239×302
$(9\frac{7}{16} \times 11\frac{7}{8})$, sheet size
Inscribed in pencil, at the bottom edge, '1814'
Turner Bequest; CCLXXX 145
D27662
W 1158

Even before the second part of his poem *Italy* was published in 1828, the wealthy poet Samuel Rogers (1763–1855) had already decided that the entire work needed to be published in a more attractive format than that of the first part published in 1821-2 and 1824, with illustrations that would stimulate interest. In 1826 he seems to have commissioned Turner to make twenty-five watercolours which would be used as designs for the engravings that appear as head- or tail-pieces to his poems (see cat.no.58).

This watercolour, based on pencil notes Turner had made in 1802 (TB LXXIV 11), takes a view from above the town of Aosta. The cross in the foreground is inscribed '1826', most probably the date the watercolour was executed, as the final engraving reverts to the date '1814' also seen here at the bottom of the sheet. A watercolour, similar in style, of 'Martigny' (TB CCLXXX 154; W 1159) was made on paper watermarked 1826, confirming the earliest possible date for Turner's involvement in this project.

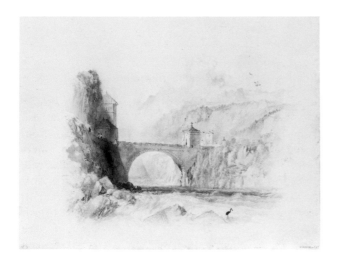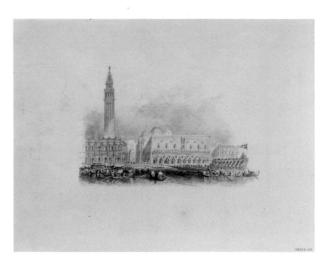

53 **St Maurice** *c.*1826–7
Watercolour and pencil
165 × 220 ($6\frac{1}{2}$ × $8\frac{11}{16}$), vignette; 236 × 296
($9\frac{5}{16}$ × $11\frac{11}{16}$), sheet size
Turner Bequest; CCLXXX 147
D27664
W 1154

The majority of the vignettes made for *Italy* conform to the oblong shape of this watercolour. This is emphasised by the fine pencil lines drawn here round the design and the series of numbers at the edge of the sheet used by the engravers for transferring the image to the steel plates (also present in TB CCLXXX 160, 166, 164, 148, 167). Hamerton writing in 1879 observed how 'if you examine a vignette by Turner round its edges, if you can call them edges, you will perceive how exquisitely the objects come out of nothingness into being . . . we feel as if a portion of the beautiful white surface had in some wonderful way begun to glow with the light of genius' (Hamerton, pp.228–9).

A preliminary study exists for this design (TB CCLXXX 1) among a series of similarly unfinished watercolours relating to the *Italy* project. The softly outlined edges of the mountains and clouds above the bridge were transformed by Robert Wallis in his engraving by the addition of more detailed effects. This kind of change in the skies of the vignettes is one of the most noticeable differences between the watercolours and their engraved versions, a process which Turner supervised in the translation of his images into black and white.

54 **Venice, The Ducal Palace*** 1827
Watercolour, with pencil annotations
127 × 184 (5 × $7\frac{1}{4}$), vignette; 240 × 306
($9\frac{7}{16}$ × $12\frac{1}{16}$), sheet size
Turner Bequest; CCLXXX 193
D27710
W 1162

In the vignettes for *Italy* Turner balances a desire to illustrate the modern Italy he recalled from his visit of 1819 with the poetry of ancient Italy which overflowed from its art and ruined monuments. This scene shows the Doge's barge, the Bucentaur, as used in the age-old ceremony of the marriage of the city with the sea, which had fallen out of use by the early nineteenth century. The lively festival atmosphere recalls Canaletto's many views of the city, and Turner was to exhibit an oil painting of a similar scene at the Royal Academy in 1833 which directly alludes to the Venetian artist ('Bridge of Sighs, Ducal Palace and Custom-house, Venice: Canaletti painting', B & J 349, Gallery 105).

The jewel-like nature of this watercolour neatly serves to illustrate lines from Rogers's poem:

> still glowing with the richest hues of art,
> As tho' the wealth within them had run o'er.

While the brilliance of this and other vignettes seem attractive to the modern eye, earlier critics found the colours exaggerated and unnatural, supposing it to have been intended to aid the engravers in translating colour into black and white. Like others in this group, the sheet contains annotations in which Turner has clarified for the engraver, in this case Edward Goodall (1795–1870), the architecture of both the campanile and the loggia of the Libreria Marciana. The six bays shown on this loggia facing the waterfront are not an accurate record of the building, and it seems likely that

Turner made the watercolour without reference to his sketchbooks in which this detail is correctly observed (see the *Milan to Venice* sketchbook, TB CLXXV f.35 verso). The loggia does, however, appear correctly delineated in the 1833 oil painting.

He has also included here subtle lighting effects, such as the slanting shadow across the side of the campanile, as well as insisting, in the engraving, on the higher lighting of the Torre dell'Orologia seen beyond St Mark's. His fastidious attention to this kind of detail was repaid by critical praise of the finished book, such as that of Walter Scott, who championed the illustrations as 'such beautiful specimens of architecture as form a rare specimen of the manner in which the art of poetry can awaken the muse of painting' (Finley, 1980, p.72).

Turner planned another view of Venice for the publication showing St Mark's and its campanile from the Piazza (TB CCLXXX 2), but this seems to have been rejected in favour of the wider view from the Bacino.

> Of all the fairest Cities of the earth
> None is so fair as Florence. 'Tis a gem
> Of purest ray . . .
> . . . Search within,
> Without; all is enchantment

the English visitor found the centre of the city unpleasant and preferred to view it from afar (see also cat.nos.79–80). The view engraved in *Italy* is taken from Fiesole (w 1163; R 359), and recalls another watercolour Turner had made around 1818 to illustrate James Hakewill's *Picturesque Tour of Italy* (w 715; R 159).

The shadow effect in this drawing recalls that in 'St Maurice' (cat.no.53) as well as some of the Petworth interiors illuminated by shafts of sunlight (see cat.no.64). Turner visited the Uffizi Gallery, partly seen here, on his 1819 visit and again in 1828, when he may have been inspired by Titian's 'Venus of Urbino' to paint his own 'Reclining Venus' (B & J 296; Reserve Galleries).

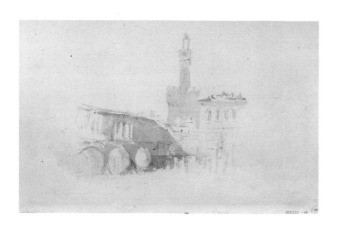

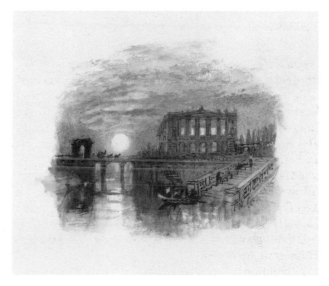

55 **The Ponte Vecchio, Florence*** *c.*1827
 Watercolour
 115×141 ($4\frac{1}{2} \times 5\frac{1}{2}$), vignette; 191×243
 ($7\frac{1}{2} \times 9\frac{9}{16}$), sheet size
 Turner Bequest; CCLXXX 95
 D27612

Rogers seems to have dictated the subjects selected for engraving in *Italy*. There are also a number of related but unfinished works (TB CCLXXX 1, 2, 6, 22, 87, 88, 92, 103, 151). This view of Florence is the most radically different of these from the watercolour which was eventually used for the project. Cecilia Powell has noted (1987, p.133–4) that although Rogers wrote in evocative terms of Florence,

56 **A Villa on the Night of a Festa di Ballo** *c.*1827
 Watercolour, with pen and traces of pencil
 95×115 ($3\frac{3}{4} \times 4\frac{1}{2}$), vignette; 246×309
 ($9\frac{11}{16} \times 12\frac{1}{8}$), sheet size
 Turner Bequest; CCLXXX 165
 D27682
 W 1175

Three of the watercolours for *Italy* are moonlight scenes, painted in deep blues with penwork in black ink. This scene is described by Rogers in his poem as a 'scene of revelry' at a villa with its 'windows blazing', and located in the text as near Genoa (not Padua as Ruskin suggested). Turner visited Genoa for the first time in

1828, after the watercolours for this publication were complete. As there are no pencil drawings which relate to this study, it is most likely that the villa is an imaginary one suggested by Rogers's poetry.

As with other watercolours in the series Turner has annotated this sheet to clarify minute details for the engraver: the outline of a second boat has been added in the darkness of the foreground by the steps, and on the bridge below the moon he has strengthened the silhouettes of the horses pulling a carriage. For *Italy*, the majority of the vignettes fit into a rectangular format (see cat.no.54). However, in this and the designs of 'Paestum' (TB CCLXXX 148; W 1173) and 'The Forum' (TB CCLXXX 158; W 1167), there is the beginning of a more circular construction.

57 **A Farewell: Lake of Como** 1827
Watercolour and pencil, pen and brown ink
130 × 200 ($5\frac{1}{8}$ × $7\frac{7}{8}$) vignette; 245 × 305 ($9\frac{5}{8}$ × 12), sheet size
Turner Bequest; CCLXXX 150
D27667
W 1176

By 1827 Turner was receiving engravers' proofs for the designs of 'St Maurice' (cat.no.53) and 'William Tell's Chapel' (TB CCLXXX 155; R 349). Rogers asked Turner to make this view, which acts as a summary of the book, while both men were on a visit to Petworth in either October or November 1827. Rogers recalled to Ruskin how he had made his request at breakfast and was provided with this watercolour at lunchtime.

Not having reference to the pencil notes he had made in Italy, Turner was forced to draw on his memory, recreating through the air and light of this subject the mood, if not the specific topography, of the Italian lakes.

58 **Rogers's Italy**
London 1830
Open at pp.46–7: 'Venice, The Ducal Palace'
Engraving by E. Goodall after Turner, later state
(R 358)
302 × 135 ($11\frac{7}{8}$ × $5\frac{5}{16}$)
Tate Gallery Library

Although containing designs after Stothard, Prout, Titian and Vasari, it was the twenty-five illustrations that Turner contributed to the 1830 edition of Samuel

Rogers's poem *Italy* which assured its immediate success. The reviews were superlative: 'This is such a volume that we fear never to look upon its like again – it beats all the annuals together. Poetry, wealth, taste, are here blended beautifully, and the result is the most splendid piece of illustrated topography it has ever been our fortune to look on' (*The Athenaeum*, no.147, 21 August 1830, p.526). The discreet reference to wealth alludes to that of the poet who from his own means was able to finance the edition. It was from the first conceived as an ambitious project, involving thirteen engravers at a time when steel-engraved book illustrations were relatively new, having only been introduced in 1822. The process of combining text with an engraved head- or tail-piece, such as that seen here, was also expensive, requiring the sheet of paper to pass through the press twice. The costs were, no doubt, soon recovered through the exceptional popularity of the book: in less than two years it had sold 6,800 copies. The book was available in two editions: one at £1 8s, and a deluxe edition at £3 3s. Alternatively, the vignettes were available separately in a portfolio, again at different prices. Rogers had originally intended to buy the watercolours for £50 each, but as a means of reducing Rogers's outlay Turner offered to lend his designs for five guineas each.

As to the literary content of the volume, one poet observed:

> Of Rogers's Italy Luttrell relates
> Twould surely be *dished*, if twernt for the *Plates*
> (quoted in C. Powell 1983, p.2)

while Wordsworth commented 'in the Poetry there is nothing – absolutely nothing', a view of Rogers's poetry not endorsed by Turner, who admired his work enough to illustrate two volumes of it, in circumstances not to his own financial gain. He was also to quote from Rogers's poems in the Royal Academy catalogue for a view of Venice exhibited in 1844 (B & J 412) and for the picture 'The Angel Standing in the Sun' (B & J 425; Gallery 101). The success of the translation of Turner's watercolours into an engraved format is readily apparent here, and the book still has the power to delight so that, like the *Athenaeum* reviewer, even a twentieth-century reader may find it 'Impossible to do anything but turn from picture to picture, from jewel to jewel'.

59 **Holy Island Cathedral** *c.*1827
Watercolour and bodycolour on blue paper
285 × 193 ($11\frac{1}{4}$ × $7\frac{5}{8}$)
Turner Bequest; CCLXXX III
D27628

When the series of *Southern Coast* views was reaching its conclusion around 1824, Turner and William Cooke seem to have discussed the prospect of continuing the project with views of the east coast of England. By the end of 1826, however, Turner and Cooke had quarrelled bitterly over the terms upon which the project should advance. Turner nevertheless determined to issue the work himself and made a series of watercolours on blue paper which were engraved by J.C. Allen, but remained unpublished (W 896–903). This watercolour showing the arches of the ruined abbey on Holy Island, Northumberland, would appear, along with several others, to be related to the project. Another vignette design on blue paper is inscribed '4 vig. for the East Coast' (TB CCLXXX 110), which could perhaps refer to itself, this sheet and two others in the Bequest (TB CCLXXX 112, TB CCLIX 265a). Turner had visited Holy Island in 1797 (TB XXXIV ff.50–5) and returned to his earlier sketches to include a view of this subject in the *Liber Studiorum* (TB CXVI N; RL 11) and in the 1820s to execute a watercolour for the *Picturesque Views in England and Wales* (W 819; R 243).

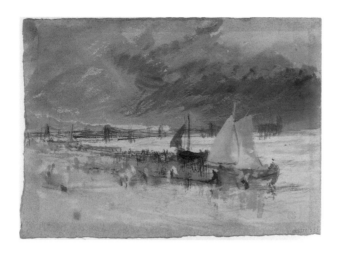

60 The Old Chain Pier, Brighton, from the West c.1827
Bodycolour and watercolour on blue paper (faded from exposure)
142 × 193 ($5\frac{9}{16}$ × $7\frac{5}{8}$)
Turner Bequest; CCXLIV 111
D22773

In 1826 Messrs John and Arthur Arch advertised a publication to be called 'THE ENGLISH CHANNEL, or LA MANCHE, to consist of views taken by [Turner] from Dunkirk to Ushant, and places adjacent'. This view of Brighton may have been made in conjunction with the scheme. Others on blue paper show scenes on the French coast, and seem to have no apparent purpose unless they are connected with the *Channel* project.

This subject echoes an oil painting by John Constable of the Chain Pier which was exhibited at the Royal Academy in 1827 (Tate Gallery). The Chain Pier was intended to provide a point where ships could unload their goods, thereby improving trade in the rapidly-growing town, which has no natural habour. However, upon completion the pier also served as the boarding point for passengers travelling from Brighton to Dieppe. Turner had made pencil sketches of the Chain Pier soon after its erection in 1823. This was a project in which the third Earl of Egremont was involved as a shareholder, and was consequently the subject of one of the four oil landscapes Turner painted for the Earl's dining room at Petworth House (B & J 291).

Both this study and another (TB CCXLIV 110) show the pier from the west, but the majority of Turner's watercolours, and both oil paintings of this subject, take a vantage point to the east of the structure (see the *Southern Coast* view, W 479, W 917 and TB CCXLIV 250 and 271).

61 Petworth House from the Lake, with Figures 1825-7
Pen and ink, watercolour and bodycolour on blue paper
143 × 191 ($5\frac{5}{8}$ × $7\frac{1}{2}$)
Turner Bequest; CCLIX 5
D24570

In the mid-1820s Turner renewed his association with his early patron the third Earl of Egremont (1751-1837), owner of Petworth House in West Sussex. Between 1827 and 1837 Turner was to become as frequent a visitor to Petworth as he had been to Farnley Hall before the death of Walter Fawkes in 1825. The use of pen and brush is a technique similar to that deployed for the series of views of the River Loire, possibly also made at about this time. Indeed, for many years this subject was identified as a French château.

Along with a similar sketch of Fittleworth Mill (TB CCLIX 41), this drawing seems to be slightly earlier than the main group of Petworth subjects, quite probably related to pencil drawings in the *Mortlake and Pulborough* sketchbook of 1825 (cat.no.42).

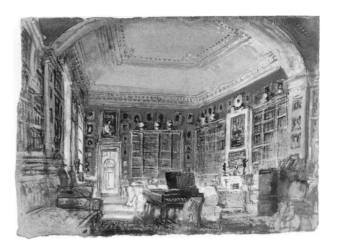

62 **The North Gallery by Moonlight** 1827
Pen and ink, watercolour and bodycolour, with
some scraping-out, on blue paper
141 × 192 ($5\frac{1}{2} × 7\frac{1}{2}$)
Turner Bequest; CCXLIV 25
D22687

Apart from the relaxed 'liberty hall' hospitality of
Petworth, the main attraction for Turner and the other
artists who visited the house was the fine collection of
paintings and sculpture. It was not a static collection:
in this picture Turner shows John Flaxman's sculpture,
'St Michael Overcoming Satan', which had only been
completed and installed in the gallery in 1826. Largely
given over to works by contemporary artists, the North
Gallery had been greatly expanded, for the third time,
in 1824. It also housed the large collection of antique
sculpture acquired by the second Earl of Egremont on
his Grand Tour in Italy, a collection to which the third
Earl added, acquiring a torso from Rome, which was
purchased on his behalf by Turner in 1828.

Turner made two coloured drawings of the North
Gallery, one in bright but diffused daylight (TB CCXLIV
13), and this dramatic moonlight study. To heighten
the drama of the scene he has increased the power of the
towering sculpture by diminishing the size of the
figures and the surrounding walls, as well as illuminating the
gallery with a bold slash of light, an effect achieved by
scraping away the surface of paint.

63 **The White Library: Looking down the
Enfilade from the Alcove** 1827
Watercolour and bodycolour, with some penwork,
on blue paper
143 × 193 ($5\frac{5}{8} × 7\frac{5}{8}$)
Turner Bequest; CCXLIV 16
D22678

The White Library was the focal point of much of
Petworth life during the years of the third Earl. At the
southern tip of the north–south axis of the house,
adjacent to the third Earl's ground-floor bedroom, the
room served as library, music room and venue for the
intimate *conversazioni* shown in many of Turner's drawings.
The library had been extended by the third Earl to
include the alcove area, from which in this drawing the
viewer looks through the open door down the length of
the west side of the house.

The Turner Bequest contains a small group of quite
detailed sketches, such as this one, which are reminiscent
of those interiors the artist had made at Farnley Hall
around 1815. Much of the decor they show can still be
found in the house today: in this drawing a series of
portraits by Thomas Phillips can be seen above the
bookcases, together with the busts of philosophers.

Detailed interior sketches of this kind at first seem out
of character for Turner, a landscape artist. But, as with
those made at Farnley, it was the special circumstances
of his association with the place that served as the
primary stimulus. At Petworth he never merely renders
the details of the place; the majority of the drawings
document his concern with atmosphere, light and
colour.

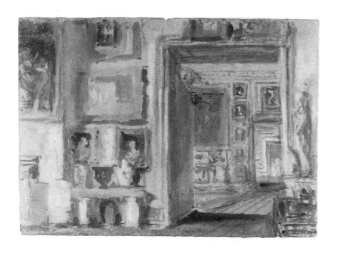

64 **The Somerset Room: Looking into the Square Dining Room and beyond to the Grand Staircase** 1827
Watercolour and bodycolour on blue paper
139 × 189 ($5\frac{1}{2}$ × $7\frac{1}{2}$)
Turner Bequest; CCXLIV 73
D22735

This drawing conveys something of the riches of Petworth, with the walls of room after room filled with canvases in gilt frames, and console tables weighed down with ornate china vases or statuary (see also TB CCXLIV 19).

Beyond the open door, in the Square Dining Room, can be seen a large canvas which, appearing in another sketch (TB CCXLIV 108), can be identified as Sir Joshua Reynolds's history painting 'Macbeth and the Witches'. In the picture on the extreme left can be made out a boy holding a bow and arrow. This is a detail from a painting by George Romney showing Elizabeth Iliffe, the mistress of the third Earl of Egremont, with their children.

65 **A Bevy of Beautiful Women** 1827
Watercolour and bodycolour on blue paper
143 × 193 ($5\frac{5}{8}$ × $7\frac{5}{8}$), uneven
Turner Bequest; CCXLIV 101
D22763

Although Turner is often accused of reclusive behaviour he clearly relished the warm, if sometimes rather haphazard, hospitality of the third Earl's household. George Jones (1786–1869) recalled how Turner was very much at home at Petworth acting as a kind of surrogate host in bidding Jones and his wife farewell at the end of one of their visits. Over forty sketches focus on the other occupants and guests of the house. Although no guest lists survive for this period the identity of some of those depicted is apparent: Lord Egremont appears in several, as well as other members of his family, the artist Sir William Beechey (see cat.no.66), and even the local vicar, the Reverend Thomas Sockett (see TB CCXLIV 86). What is most appealing in these sketches is the subtle revelation of character and manner, whether this is the after-dinner banter of men around the fireplace (TB CCXLIV 82), the pacing of a colonel in his red uniform (TB CCXLIV 22), the involvement of the fortepiano player in her music (TB CCXLIV 37), the hungry anticipation before dinner (TB CCXLIV 31), or the feminine exchanges shown in this image.

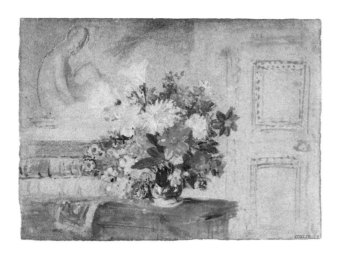

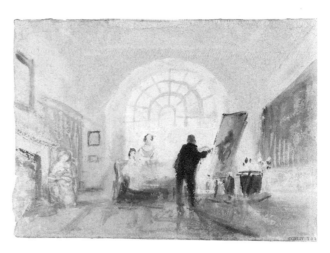

66 The Old Library: A Vase of Lilies, Dahlias and Other Flowers* 1827
Watercolour and bodycolour on blue paper
139 × 188 ($5\frac{1}{2}$ × $7\frac{1}{2}$)
Turner Bequest; CCXLIV 23
D22685

67 The Artist and his Admirers* 1827
Watercolour and bodycolour on blue paper
138 × 190 ($5\frac{1}{2}$ × $7\frac{1}{2}$)
Turner Bequest; CCXLIV 102
D22674

After his visit in 1827 the Old Library became Turner's private studio where he was able to work behind locked doors only interrupted by Lord Egremont himself.

At the time of this visit the room was clearly used by other artists, as Turner's own drawings reveal (see TB CCXLIV 103, 29, 20, and 42). Artists visiting the house were permitted to move pictures to the Old Library and even to their bedrooms. The statue in the background here is a 'Seated Venus' by Joseph Nollekens. The old volumes and the print draped on the table in this sketch demonstrate the other kinds of stimuli Turner found in the room.

The flowers shown in this drawing were almost certainly arranged for study by the portrait artist Sir William Beechey, who was working on a picture of Egremont's niece, 'Mrs Hasler as Flora'. Indeed the vase of flowers, and this portrait by Beechey appear in another of Turner's drawings (TB CCXLIV 20). The great variety of flowers shown here is most probably due to the large conservatory then attached to Petworth House, but since demolished. Although such attention to flora is often overlooked in discussions of Turner's work, his sketchbooks reveal that he frequently recorded this kind of information (see the *Walmer Ferry* sketchbook, TB CXLII f.8; the *Old London Bridge and Portsmouth* sketchbook, TB CCV f.1 verso; and the *Petworth* sketchbook, TB CCXLIII ff.79–82).

A fanlight window similar to that seen in this drawing is to be found in the Old Library, the room above the chapel on the east side of Petworth House which was later to become Turner's studio. In both this and another drawing (TB CCXLIV 29) the lower half of the window is boarded up to limit the amount of daylight. The two drawings reveal considerable differences in the treatment of the glazing of this window – the other sheet bearing the horizontal and vertical mullions still present. In this drawing, however, Turner departs from his usual accuracy of architectural detail and the drawing may be a fantasy.

68 A Lady in Black Dress at her Toilet 1827
Watercolour and bodycolour on blue paper
138 × 190 (5½ × 7½)
Turner Bequest; CCXLIV 79
D22741

As in other figure studies made at Petworth, Turner has chosen to paint this young woman from behind, capturing a moment of unselfconscious absorption. Although the spectator is able to see her face reflected in the mirror, she seems too preoccupied with what appears to be a letter to notice the painter's presence. Turner creates the shady impression of her reflected visage with the help of a thumb or finger print.

This image has affinities with the oil painting 'Two Women with a Letter' (B & J 448) in which the back of a woman's neck and shoulders are depicted in a comparable way. A pencil drawing of a similar composition (TB CCCXLIV 350) displays echoes of the French artist Watteau. Another 'French' influence may well have been Richard Parkes Bonington (1802-1828), then working in Paris, and it has been suggested that Turner's concentration on the figure in studies such as this and similar subjects made in France (see TB CCLIX 28, 190, 197, 263, 270) owe their origin to Bonington's example.

69 A Bedroom at Petworth House 1827
Watercolour and bodycolour on blue paper
138 × 190 (5½ × 7½)
Turner Bequest; CCXLIV 75
D22737

Turner was clearly at liberty to wander through both the public and private rooms at Petworth. Both this drawing and cat.no.68 form part of a group depicting some of the bedrooms. Many of them include more of the picture collection either hung round the walls or propped casually against the backs of chairs. In this drawing and another (TB CCXLIV 72), a Japanese lacquer cabinet can be seen, upon which rests a blue vase. Although both drawings seem to show the same room Turner varies the colour of the bedcurtains, so that in this one they are green, while the other has curtains of bright yellow. In many of the bedroom scenes the atmosphere is one of charged intimacy, a theme also pursued in colour notes in two sketchbooks (TB CCXCI (b) and (c)). But despite the faintly erotic nature of these drawings, Turner is as much concerned with the quality of light, noting in this study the deep, almost blue, folds of the bedcurtains.

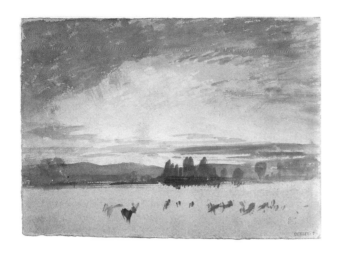

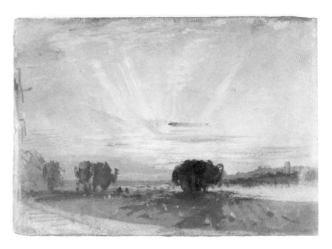

70 The Deer in Petworth Park 1827
Watercolour and bodycolour on blue paper
140 × 190 ($5\frac{1}{2}$ × $7\frac{1}{2}$)
Turner Bequest; CCXLIV 7
D22669

The parklands at Petworth were referred to by one contemporary as a 'college of agriculture' in which Lord Egremont experimented with the advantages of various breeds of livestock and different types of feed. Turner's 1827 visit seems to have generated a commission for four elongated landscapes to decorate the dining room, known as the Carved Room. By August 1828 he had completed two views of the park, both of which show the deer also seen in this drawing (B & J 288, 289). Several of the coloured drawings include the deer grazing, while other kinds of livestock are also depicted, such as the fine racehorses kept by Egremont (TB CCXLIV 113), and the bullocks and donkeys used for carting work (TB CCXLIV 97, 87, 107 and W 912).

71 Sunset across the Park from the Terrace of Petworth House 1827
Watercolour and bodycolour on blue paper
140 × 193 ($5\frac{1}{2}$ × $7\frac{9}{16}$)
Turner Bequest; CCXLIV 2
D22664

The sunset light of many of Turner's depictions of Petworth Park was to be an important liberating influence contributing to the rich and dramatic colouring of exhibited oil paintings, such as 'Ulysses Deriding Polyphemus' (B & J 330).

The project of four landscapes for the Carved Room of Petworth House was preceded by four preliminary versions of the same scenes (B & J 283–6; Gallery 102). This study anticipates quite closely part of the view made from the terrace looking towards the lake in which Lord Egremont is seen greeted by his dogs as he returns to the house (B & J 283). The facade of the house can be seen on the left-hand edge of this sheet – the pinkish strip disappearing between the trees indicating the old coachway, in service while the Marble Hall on the west front was used as the main entrance. This sketch, containing about two-thirds of the total view from the terrace, seems to be an intervening stage between the more detailed pencil notes made in the *Petworth* sketchbook (TB CCXLIII ff.76 verso, 77, 77 verso and 78) and in loose paper sketches (TB CCCXLI 225 and 380), and the final panoramic sweep of the oil painting.

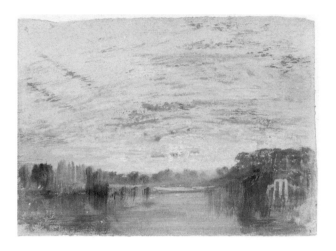

73 (?) The Upperton Monument Seen from Petworth Park 1827
Watercolour and bodycolour on blue paper
139×185 ($5\frac{1}{2} \times 7\frac{3}{8}$)
Turner Bequest; CCLIX 234
D24799

This drawing was formerly grouped with those made for the *Rivers of Europe* project, but seems to depict the Upperton Monument, a folly still to be seen in Petworth Park. This is thought to have been designed for Lord Egremont by Sir John Soane. Turner had made pencil sketches from and near the monument in his *Mortlake and Pulborough* sketchbook, the tower providing a superb vantage point overlooking the park. One sketch shows the building itself (TB CCXIII 19).

72 Sunset Sky over the Lake 1827
Bodycolour and watercolour on blue paper
139×191 ($5\frac{1}{2} \times 7\frac{1}{2}$)
Turner Bequest; CCXLIV 3
D22665

Turner spent many hours while at Petworth fishing in the artificially created lake (a product of Capability Brown's landscaping), enjoying a friendly rivalry with other visitors such as the sculptor Sir Francis Chantrey. One story recounts how he made a paper boat from a leaf of one of his sketchbooks for the son of the artist Charles Robert Leslie (Finberg 1961, p.349).

The brushwork in this study is particularly fine, bringing to mind the subtlety of the skies the artist created in his watercolours for the *Rivers of England*. The scene is vividly recreated, including the boathouse on the right.

Turner executed another view of this part of the lake (W 911), as well as making a detailed pencil sketch of the view for a lady related to Lord Egremont then visiting the house (see cat.no.76).

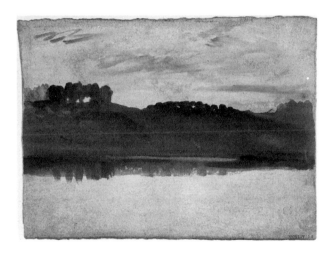

74 Sunset over the Ridge Seen from the North Pond in Petworth Park 1827
Bodycolour and watercolour on blue paper
139×188 ($5\frac{1}{2} \times 7\frac{1}{2}$)
Turner Bequest; CCXLIV 12
D22674

Several of the sketches of Petworth Lake are similar in style and colouring to the drawings Turner made of the River Loire, suggesting that the latter were painted around or soon after 1827–8. In many of the drawings he was deliberately utilising the natural blue of the paper to evoke the sky, or as a neutral ground tone for his interior views, but in this sketch he has almost obscured the foreground with a wash of white bodycolour to denote the reflected sky. The intensity of the sunset colours found in other Petworth subjects is here rather muted, the soft tones subdued by the dark green and black suggesting the silhouette of the ridge above the quiet stretch of water.

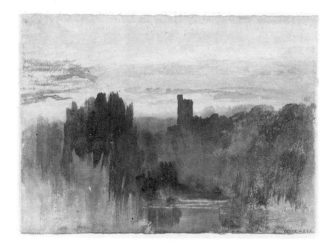

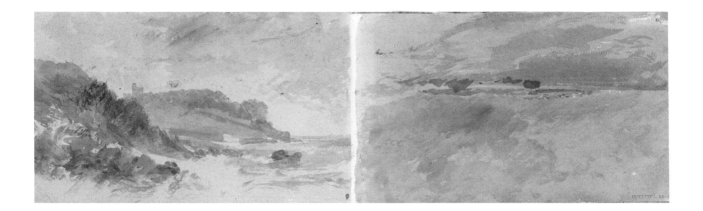

Isle of Wight sketchbook 1827

75 **A Rocky Headland with the Central Tower of East Cowes Castle;** (upside down) **A Rocky Shoreline**
Watercolour and bodycolour (the subject on f.32 is white paper prepared with a grey wash)
110 × 185 ($4\frac{3}{8}$ × $7\frac{3}{8}$)
Watermarked: J & R ANSELL/1817
Turner Bequest; CCXXVII ff.31 verso, 32
D20782, D20783

In the summer of 1827, after a brief stay at Petworth, Turner visited East Cowes Castle on the Isle of Wight. This was the home of the architect John Nash, who had also designed and built the castle. Turner made many sketches of it, both on blue paper similar to those he made at Petworth (see TB CCXXVII(a)) and in sketchbooks. In this book he explores the shoreline of the island, occasionally recording the distant towers of the castle. Another colour view of the tower and a rocky headland can be found on f.43. As with the *Trèves and Rhine* sketchbook (cat.no.44), many of the leaves in this book have been prepared with a grey wash.

76 **Cowes Harbour** 1827
Pencil on Turnball's Superfine London Board (as stamped)
145 × 219 ($5\frac{3}{4}$ × $8\frac{1}{2}$)
Inscribed in pencil: 'JMWT'
Private Collection

While at East Cowes in 1827 Turner completed the two oil paintings of the Regatta and John Nash's castle exhibited at the Royal Academy in 1828 (B & J 242-3). The experience of the Regatta provided the stimulus for another picture, 'Dido Directing the Equipment of the Fleet, or the Morning of the Carthaginian Empire', also exhibited at the Royal Academy (B&J 241), the seeds of which can be found in pen and ink studies made at East Cowes (TB CCLX 7, 8, 15). Many of these pen and ink studies also focus on shipping activity (TB CCLIX 31, 32, 35, 36).

This pencil drawing is one of a small number of highly-finished subjects made by Turner as gifts in 1827 or 1828. According to an accompanying letter, this and cat.no.77 were made for Harriet Petrie (1784-1849), later the wife of Thomas Bosvile Bosvile (the 'Aunt Bosvile' referred to on the mount), then on a visit to East Cowes Castle. Another drawing presented by Turner to a lady was that of Petworth Lake which he made for Julia Hasler, the niece of Lord Egremont (see *Turner at Petworth*, repr., p.128). Two related subjects exist, both of shipping, in the Vaughan Bequests at Edinburgh and Dublin. It was generally not Turner's practice to sign his works so prominently, but all five of these drawings are signed with his initials, and in the case of the Petworth view with his full surname.

Turner also made a watercolour of West Cowes at about this date which was engraved in 1830 for the *Picturesque Views in England and Wales* (W 816; R 240).

77 Man of War and Cutter 1827
Pencil
140 × 188 ($5\frac{1}{2}$ × $7\frac{3}{8}$)
Inscribed in pencil, 'JMWT'
Private Collection

Like cat.no.76, this pencil drawing was made as a gift while Turner was visiting East Cowes Castle. The fine and deliberate pencil work is similar to a group of sketches of boats in the Turner Bequest (TB CCIII E, F, G, formerly one sheet; TB CCIII H, I, which were also previously attached). This subject also resembles the scenes of shipping made for the *Ports of England*. Turner was preoccupied with shipping throughout his career, but during the 1820s, especially in the designs of the *Southern Coast*, the *Ports of England* and the *Marine Views*, this becomes a concentrated aspect of his work. As well as drawing on the hundreds of pencil sketches made in front of different vessels he saw, Turner was able to study details from model ships he owned (Gallery 103).

78 Florence from San Miniato: preparatory study *c*.1827
Watercolour
328 × 486 ($12\frac{7}{8}$ × $19\frac{1}{8}$)
Watermarked: J WHATMAN/TURKEY MILLS/1819
Turner Bequest; CCLXIII 16
D25138

Even before Turner had visited Florence for the first time in 1819 he had been involved in producing a series of watercolours, based on drawings by James Hakewill, published in 1819 as the *Picturesque Tour of Italy* (W 700–17). One of these was a view of 'Florence from the Chiesa al Monte' (W 714) with a viewpoint not dissimilar to that of this study.

Before he visited Italy a second time in 1828, Charles Heath commissioned Turner to make a watercolour of Florence to be engraved in his new annual *The Keepsake* (see cat.no.80). This study seems to be an intervening stage between pencil notes in the *Rome and Florence* sketchbook (TB CXCI f.62) and the final watercolour.

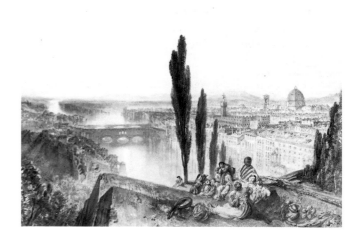

79 Florence, from San Miniato *c*.1827
Watercolour
290 × 425 ($11\frac{7}{16}$ × $16\frac{3}{4}$)
Herbert Art Gallery and Museum, Coventry (845)
W 727

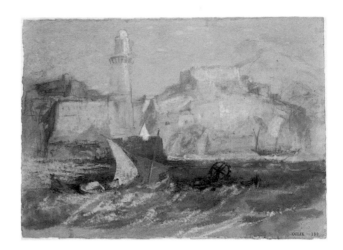

The poem which accompanied this subject in the *Keepsake* alludes to a 'silent lute' and the glories of Florence's past, all features included or evoked in Turner's watercolour.

80 The Keepsake for 1828

London 1827
Open at p.265: 'Florence from San Miniato'
Engraving by E. Goodall after Turner, later state
R 319: 194 × 127 ($7\frac{5}{8}$ × 5)
Engraved inscriptions: below, with title, names of artist and engraver and 'Pubd by T.Hurst & Co St Paul's Churchyard and R.Jennings, 2 Poultry' and 'Printed by McQueen'
Iain Bain

The design of 'Florence', executed for Heath's 1828 *Keepsake* annual, was the first Turner contributed to the new publication, but initiated an involvement which continued until 1837. Turner was clearly satisfied with the design in its engraved form, writing to Heath from Rome to wish him 'the Compliments of the season Keepsake &c' (Gage 1980, no.145). His journey to Rome in 1828 also occasioned an opportunity to revisit Florence where he redrew this view again and again, despite the completion of the watercolour before he left for Italy (see the *Genoa and Florence* sketchbook, TB CCXXXIII ff.44, 71, 77, 77 verso, 78, 78 verso, 79 and 79 verso).

The watercolour is also unusual in Turner's *oeuvre* in being a subject that he repeated almost exactly on at least two occasions: in a version for Thomas Griffith (W 727), and also for his patron H.A.J. Munro of Novar (W 728).

The figures engaged in a kind of *fête champêtre* are reminiscent of Watteau, their costumes also resembling those in the oil painting 'Boccaccio Relating the Tale of the Birdcage', exhibited at the Royal Academy in 1828 (B & J 244), and it may be that Turner was suggesting an allusion to Boccaccio in this subject – an enchanted garden above Florence being the setting for the writer's *Decameron*.

81 The Lighthouse at Marseilles from the Sea

c.1828
Watercolour, bodycolour and penwork with scraping-out on grey paper
142 × 190 ($5\frac{9}{16}$ × $7\frac{1}{2}$)
Turner Bequest; CCLIX 139
D24704

Turner's route to Rome in 1828 was an unusual one taking him across much of France from Paris to Orleans and Lyons, thence to Marseilles and next by boat along the coast via Genoa to Livorno. In Italy he travelled across country to stop at Pisa, Florence, Siena and Orvieto before finally arriving at Rome itself. The journey took him nearly two months during the humid days of August and September. Turner complained in a letter to George Jones: 'I must see the South of France, which almost knocked me up, and the heat was so intense, particularly at Nismes and Avignon; and until I got a plunge into the sea at Marseilles, I felt so weak that nothing but the change of scene kept me onwards to my distant point' (Gage 1980, no.141).

This, and the following group of drawings (cat. nos.82–84), relate to sketches in the books Turner used on this trip (TB CCXXIX–CCXXXIV) and were presumably made sometime after the journey. Drawings of the lighthouse at Marseilles appear in the *Lyons to Marseilles* sketchbook (TB CCXXX). A similar coloured drawing of the harbour and lighthouse is TB CCXCII 74, while another sheet listed as 'Coast of Genoa' includes the same bold use of emerald green for the sea (TB CCXCII 33).

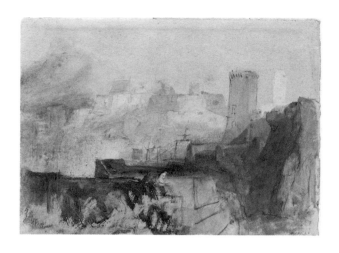

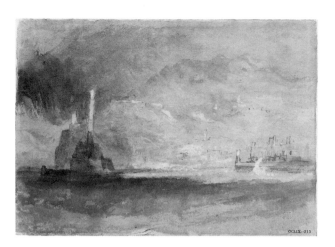

82 **Marseilles: In the Port** *c*.1828
Watercolour, bodycolour and penwork on grey
paper
139 × 189 (5½ × 7½)
Turner Bequest; CCXCII 80
D29031

Like cat.no.81, this sheet shows the harbour and
fortifications in the old port of Marseilles. There are
pencil sketches suggesting the mass of buildings above
the port in the *Lyons to Marseilles* sketchbook (TB
CCXXX). In the more finished of these French coast
views Turner has often deployed a vigorous red outline
penwork not dissimilar to that used in the watercolours
for his *Annual Tour – the Loire*. However, there appears to
be no specific publication with which these coastal
views of southern France and Italy can be readily
associated.

83 **Genoa from the Sea*** *c*.1828
Watercolour, bodycolour and penwork on grey
paper
139 × 190 (5½ × 7½)
Turner Bequest; CCLIX 213
D24778

This watercolour is based on pencil sketches of Genoa
harbour made from the sea in the *Marseilles to Genoa* and
the *Coast of Genoa* sketchbooks (TB CCXXXI, CCXXXII).
The dramatic positioning of the tall lighthouse fasci-
nated Turner and is prominent in all his studies of the
town.

Turner painted a view of Genoa for Edward Finden's
1832–4 edition of *The Works of Lord Byron*. That
illustration also shows the harbour dominated by its
lighthouse, with a boat full of fishermen in the fore-
ground (W 1231; R 427). Genoa was also the subject
of a watercolour made right at the end of Turner's
career (W 1569, now in the City Art Gallery,
Manchester).

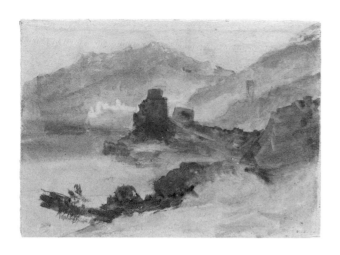

Genoa and Florence sketchbook 1828

84 **Ruins and Cliffs on the Mediterranean Coast*** *c.*1828
Pencil, watercolour and bodycolour on grey paper
139 × 190 $(5\frac{1}{2} × 7\frac{1}{2})$
Turner Bequest; CCXCII 71
D29022

Many of the colour sketches resulting from the water-borne journey along the Mediterranean coast are striking for their vivid and often unusual use of colour. Turner's palette, awakened to the sultry colours of southern France in high summer, is rich is pinks, lilacs, vermilions and ochres, softened through their relation-ship with more earthy tones.

The rugged appearance of the French and Italian coast stimulated Turner's imagination more in the watercolours resulting from the journey than in his immediate pencil drawings. He wrote home to Eng-land: 'Genoa, and all the sea-coast from Nice to Spezzia is remarkably rugged and fine; so is Massa. I ell that fat fellow Chantrey [the sculptor] that I did think of him, *then* (but not for the first or the last time) of the thousands he had made out of those craggs which only afforded me a sour bottle of wine and a sketch' (Gage 1980, no.141).

85 **Santa Maria della Spina on the River Arno**
Pencil on lined wove paper
143 × 97 $(5\frac{5}{8} × 3\frac{13}{16})$
Turner Bequest; CCXXXIII f.55
D21519

On the way to Rome in 1828 Turner visited Pisa, sketching the duomo and its leaning campanile (TB CCXXXIII f.59 verso). He also executed this view of Santa Maria della Spina, the Gothic church on the banks of the Arno. This was a subject he would later return to in 1832 for a watercolour vignette engraved for *The Works of Lord Byron* (W 1219; R 415). During the early 1820s Turner had made a group of seven vignettes which were used in the 1825 edition of *Lord Byron's Works* published by John Murray (W 1211–16, 1218), and he had also illustrated Byron's poetry with a view of the Acropolis for Walter Fawkes (W 1055).

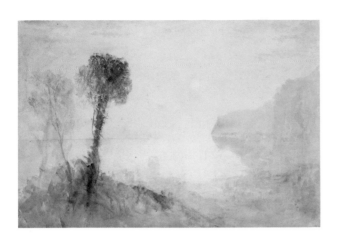

86 Study of a Classical Landscape: ?Lake Maggiore *c.*1828–30
Watercolour
312 × 439 (12¼ × 17¼)
Turner Bequest; CCLXIII 189
D25311

This colour study has much in common with a watercolour of 'Arona, Lago Maggiore' (W 730), although the trees are placed more centrally in this view and there is only the suggestion here of the turrets of the town below. The purple cliff on the right-hand side is also difficult to equate with the topography of the Italian lakes. Another colour study with this feature is TB CCCLXV 29.

Like the watercolour of 'Florence' (see cat.no.79), 'Arona, Lago Maggiore' was engraved for *The Keepsake*. Charles Heath, who published this annual, seems originally to have intended Turner's watercolours to contribute to a project containing Italian scenery in a publication similar in scope to that of the *Picturesque Views in England and Wales*, upon which both he and Turner were then engaged. This may explain the occurrence of a number of preparatory watercolours with ostensibly Italianate subjects (see also TB CCLXIII 33, 45, 46, 323).

Rouen sketchbook 1829

87 Mont St Michel, Normandy
Pencil
116 × 182 (4⁹⁄₁₆ × 7⅛)
Watermarked: IVY MILL/1816
Turner Bequest; CCLV f.17
D24106

Turner arrived in London from Italy in February 1829 and was immediately hopeful of travelling south again that year. However, this was not to be. Instead in August he travelled up the Seine to Paris, before heading along the coast of Normandy and returning via the Channel Islands.

This tour in France also included Mont St Michel, a granite island lying in the silted estuary of the rivers Sélune and Couesnon between Granville and St Malo. Among the buildings on the mount are the Romanesque church and abbey founded in the eleventh century. The isle forms a picturesque companion to the similarly named island off the Cornish coast which Turner had also painted (cat.no.25). Drawings of the French island also occur from a number of angles in the *Coutances and Mt St Michel sketchbook* (TB CCL ff.16 verso, 25 verso, 26, 27 verso).

Bibliography

All books published in London unless otherwise stated.

Bachrach, A.G.H., *Turner in Rotterdam, 1817, 1825, 1841*, Rotterdam, 1974

Butlin, M., and Joll, E., *The Paintings of J.M.W. Turner*, revised edition, New Haven and London, 1984

Butlin, M., Luther M., and Warrell I., *Turner at Petworth: Painter and Patron*, 1989

Dupret, M-E., 'Turner's "Little Liber"', *Turner Studies*, vol.9, no.1, 1989, pp.32–47

Finberg, A.J., *A Complete Inventory of the Drawings of the Turner Bequest: with which are included the Twenty-three Drawings Bequeathed by Mr. Henry Vaughan*, 2 vols., 1909

Finberg, A.J., *The Life of J.M.W. Turner, R.A.*, second edition revised, and with a supplement, by Hilda F. Finberg, Oxford, 1961

Finley, G., 'Turner: An Early Experiment with Colour Theory', *Journal of the Warburg and Courtauld Institute*, XXX, 1967, pp.357–66

Finley, G., 'A "New Route" in 1822. Turner's Colour and Optics', *Journal of the Warburg and Courtauld Institute*, XXXVI, 1973, pp.385–90

Finley, G., 'J.M.W. Turner's Proposal for a "Royal Progress"', *Burlington Magazine*, CXVII, 1975, pp.27–35

Finley, G., *Landscapes of Memory: Turner as Illustrator to Scott*, London, 1980

Finley, G., *Turner and George the Fourth in Edinburgh, 1822*, London, 1981

Gage, J., *Colour in Turner: Poetry and Truth*, London 1969

Gage J. (ed.), *Collected Correspondence of J.M.W. Turner, with an Early Diary and a Memoir by George Jones*, Oxford, 1980

Gage, J. (ed.), 'Further Correspondence of J.M.W. Turner', *Turner Studies*, vol.6, no.1, pp.2–9

Gage, J., *J.M.W. Turner: 'A Wonderful Range of Mind'*, New Haven and London, 1987

Hamerton, P.G., *The Life of J.M.W. Turner, R.A.*, London, 1885

Herrmann L., *Turner Prints*, London, 1990

Holcomb, A.M., 'A Neglected Classical Phase of Turner's Art: His Vignettes to Rogers's *Italy*', *Journal of the Warburg and Courtauld Institute*, vol.32, 1969, pp.405–10

'M.I.H.', 'The Use of Indigo. Turner's Drawings', *Turner Studies*, vol.5, no.1, 1985, pp.25–6

Powell, C., 'Turner's Vignettes and the Making of Rogers' "Italy"', *Turner Studies*, vol.3, no.1, 1983, pp.2–13

Powell, C., *Turner in the South: Rome, Naples, Florence*, New Haven and London, 1987

Powell, C., *Turner in the Rhineland and the Ardennes*, forthcoming exhibition catalogue, 1991

Rawlinson, W.G., *The Engraved Work of J.M.W. Turner, R.A.*, 2 vols., London, 1908, 1913

Reynolds, G., 'Turner at East Cowes Castle', *Victoria and Albert Museum Yearbook*, 1, 1969, pp.67–79

Ruskin, J., *The Works of John Ruskin*, Library edition, edited by E.T. Cook and Alexander Wedderburn, 1903–12

Shanes, E., *Turner's Picturesque Views in England and Wales 1825–1838*, 1979

Shanes, E., *Turner's Rivers, Harbours and Coasts*, 1981

Shanes, E., 'Turner's "Unknown" London Series', *Turner Studies*, vol.1, no.2, 1981, pp.36–42

Shanes, E., 'The Mortlake Conundrum', *Turner Studies*, vol.3, no.1, 1983, pp.49–50

Shanes, E., 'New Light on the "England and Wales" Series', *Turner Studies*, vol.4, no.1, 1984, pp.52–4

Shanes, E., *Turner's England 1810–38*, 1990

Wilkinson, G., *Turner's Colour Sketches, 1820–34*, 1975

Wilton, A., *The Life and Work of J.M.W. Turner*, 1979

Wilton, A., *Turner Abroad: France, Italy, Germany, Switzerland*, 1981

Wilton, A., *Turner in his Time*, 1987

Wilton, A., 'The "Keepsake" Convention: *Jessica* and Some Related Pictures', *Turner Studies*, vol.9, no.2, 1990, pp.14–33

Whittingham, S., 'What You Will; Or Some Notes Regarding the Influence of Watteau on Turner and Other British Artists', Parts (1) and (2), *Turner Studies*,

vol.5, no.1, 1985, pp.2–24 and vol.5, no.2, 1985, pp.28–48

Youngblood, P., '"That house of art": Turner at Petworth', *Turner Studies*, vol.2, no.2, 1982, pp.16–33

EXHIBITION CATALOGUES

Centre Culturel du Marais, Paris, *Turner en France: watercolours, paintings, drawings, engravings and sketchbooks*, various authors. 6 October 1981–6 January 1982

Tate Gallery, *Colour into Line: Turner and the Art of Engraving*, Anne Lyles and Diane Perkins, 4 October 1989–21 January 1990.